Art in Context

Delacroix : The Death of Sardanapalus

Art in Context

Edited by John Fleming and Hugh Honour

Each volume in this series discusses a famous painting or sculpture as both image and idea in its context – whether stylistic, technical, literary, psychological, religious, social or political. In what circumstances was it conceived and created? What did the artist hope to achieve? What means did he employ, subconscious or conscious? Did he succeed? Or how far did he succeed? His preparatory drawings and sketches often allow us some insight into the creative process and other artists' renderings of the same or similar themes help us to understand his problems and ambitions. Technique and his handling of the medium are fascinating to watch close up. And the work's impact on contemporaries and its later influence on other artists can illuminate its meaning for us today.

By focusing on these outstanding paintings and sculptures our understanding of the artist and the world in which he lived is sharpened. But since all great works of art are unique and every one presents individual problems of understanding and appreciation, the authors of these volumes emphasize whichever aspects seem most relevant. And many great masterpieces, too often and too easily accepted and dismissed because they have become familiar, are shown to contain further and deeper layers of meaning for us.

Art in Context

*Eugène Delacroix was born at Charenton-Saint-Maurice on 26 April 1798 and
died in Paris on 13 August 1863. His father was an ambassador and
government official (briefly Foreign Minister): his mother was the daughter of the
famous royal ébéniste J-F. Oeben. The former died in 1805, the latter in
1814. From 1815 Delacroix studied painting under Guérin, met Géricault who passed
on to him his first important commission, and from 1822 exhibited at the Salon.
His unique combination of fiery temperament and extreme refinement of sensibility
found expression in a long series of masterpieces – battles, hunts, animals in
combat, portraits, landscapes and large 'machines' – for which he drew widely on
contemporary literature and life for subjects, notably the Greek War of
Independence and, after a visit to North Africa in 1832, scenes of Arab life. His early
supporters included Thiers but his work always aroused violent opposition,
especially from those who admired Ingres and recognized in Delacroix the leader of the
Romantic painters (though he explicitly rejected the role). It is significant
that it was not until 1857 that he was finally elected to the Académie des
Beaux-Arts though he had been given large and prominent government commissions
throughout his life: the Salon d'Apollon ceiling in the Louvre and decorations in the
Chamber of Deputies and Senate.*

*The Death of Sardanapalus was painted in oil on canvas (395 x 495 cm.). Begun
in 1827 it was not ready for the opening of the Salon in November but was
accepted and hung in February 1828. It aroused a storm of criticism and remained
unsold. In 1845 an English collector, John Wilson, bought it from Delacroix
and it subsequently passed through various collections in England and France until it
was acquired by the Louvre in 1921. Several sketches, including one in oils,
are also in the Louvre. A reprise by Delacroix of 1844 is in the Henry P. McIlhenny
Collection, Philadelphia.*

Allen Lane

Delacroix: The Death of Sardanapalus

Jack J. Spector

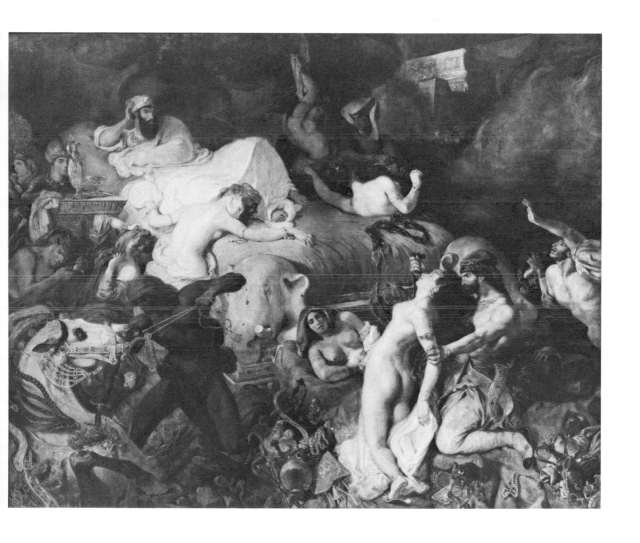

First published in 1974

Allen Lane
A Division of Penguin Books Ltd
17 Grosvenor Gardens, London SW1
ISBN 0 7139 0652 9
Filmset in Monophoto Ehrhardt by Oliver Burridge Filmsetting Ltd, Crawley, England
Color plate reproduced and printed by Colour Reproductions Ltd, Billericay, England
Printed and bound by W. & J. Mackay Ltd, Chatham, England
Designed by Gerald Cinamon and Paul McAlinden

To Helga, Robert, Elisabeth and Erik

Reference color plate at end of book

Acknowledgments

A grant from the Rutgers Research Council enabled me to travel to France in 1971 to complete my documentation.

At the Cabinet des Dessins (Louvre) M. Sérullaz encouraged my work, as did M. Adhémar at the Cabinet des Estampes (Bibliothèque Nationale), with both of whom I was fortunate enough to converse at length. Mme Monnier at the Cabinet des Dessins helped me read an almost illegible scribble of Delacroix's.

In the Kunsthalle, Bremen, Dr Busch generously made all the Delacroix materials available to me at short notice.

Professor Weitzmann at Princeton illuminated a number of points of Byzantine iconography of the Sardanapalus theme in a long conversation.

Enlightening discussions with my colleague at the University of Tours, Professor Lafond, helped me on certain questions, and Professor Lieber, also at Tours, provided valuable information.

At Rutgers the Interlibrary Loan staff and Mr Tarman of the Art Library always cooperated to the fullest.

I am especially grateful to my editors, John Fleming and Hugh Honour, who with their critical acuity and erudition contributed substantially to the coherence and validity of this book.

Historical Table

	
1820	Prince Regent succeeds as George IV. Duc de Berry assassinated.
1821	Death of Napoleon. Greek War of Independence begins.
1822	Massacre of Chios.
1823	France invades Spain and restores Ferdinand VII to throne.
1824	Charles X succeeds Louis XVIII.
1825	
1826	Return of Jesuits to France.
1827	Russia, Britain and France recognize Greece.
1828	Turks agree to withdraw from Greece.
1829	Charles X appoints ultra-conservative Prime Minister (Prince de Polignac).
1830	July Revolution.

Géricault's *Raft of the 'Medusa'* exhibited in London.	Keats, *Eve of St Agnes* and *Ode to a Nightingale*. Lamartine, *Méditations poétiques*. Shelley, *Prometheus Unbound*.	1820
Constable, *The Haywain*.	Byron, *Sardanapalus*. Weber, *Der Freischütz*.	1821
Delacroix, *Dante and Virgil* (his first Salon exhibit).	A. de Vigny, *Poèmes*. Schubert, *Unfinished Symphony*.	1822
Ingres, *La Source*.	Stendhal, *Racine et Shakespeare*. Scott, *Quentin Durward*.	1823
Delacroix, *Massacre of Chios*; Ingres, *Vow of Louis XIII*. Géricault and Girodet die.	Byron dies at Missolonghi.	1824
Delacroix in England. J.-L. David dies.		1825
Delacroix, *Justinian* for Conseil d'Etat (destroyed 1871).	A. de Vigny, *Cinq Mars*. V. Hugo, *Cromwell*.	1826
Turner, *Ulysses Deriding Polyphemus*; Ingres, *Apotheosis of Homer*.	Heine, *Buch der Lieder*. Schubert, *Winterreise*.	1827
Delacroix: *The Death of Sardanapalus* Constable, *Dedham Vale*	Béranger imprisoned for writings offensive to Charles X.	1828
	V. Hugo, *Les Orientales*. Mérimée, *Charles IX*. Balzac, *Les Chouans*.	1829
Delacroix, *Liberty Guiding the People*. Daumier begins to publish in *La Caricature*.	V. Hugo, *Hernani* performed. Berlioz, *La Symphonie Fantastique*. Stendhal, *Le Rouge et le Noir*.	1830

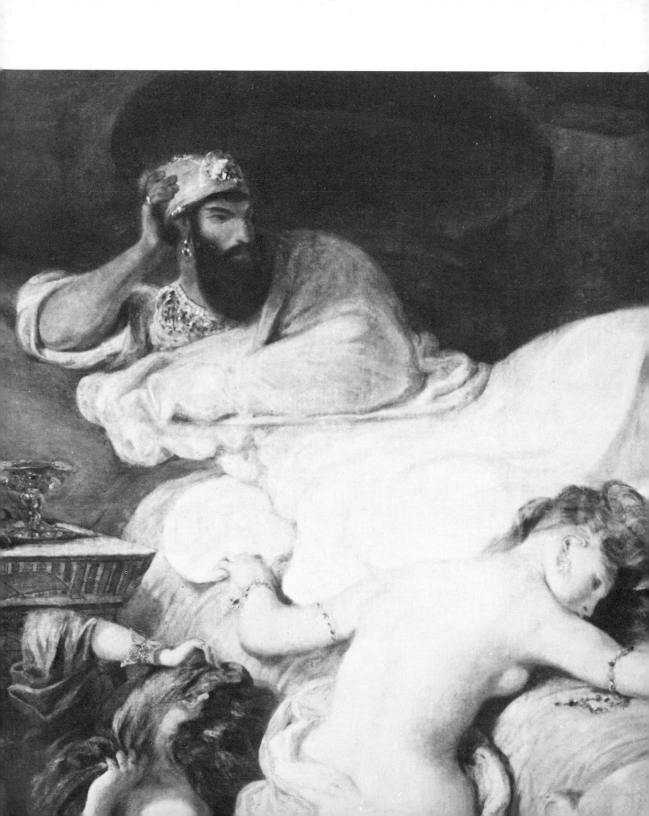

1 . Introduction

'The picture of decadence of the period, the chaos and confusion, literature in painting, painting in literature, prose in verse, verse in prose, the passions, nerves, weaknesses of our time, the modern torment...'[1] Though Nietzsche may never have seen the original none corresponds more closely with this description of Delacroix's *oeuvre* than *The Death of Sardanapalus* [see color plate at end of book]. Painted between 1827 and 1828, it is one of the most striking and at the same time most controversial of all French Romantic works of art. In size (3.95 by 4.95 metres, roughly 13 by 16 feet) it can be compared to his other major salon paintings, such as *The Massacre of Chios* (1824) and *The Justice of Trajan* (1840). But when first exhibited it met with a still more generally hostile critical reception than those works. And whereas they were promptly bought by the state, it remained in the artist's studio until 1845 and was little seen until acquired by the Louvre in 1921 when it immediately took its place among the outstanding masterpieces of French art.

The big, impressive work shows in profile a bearded man, Sardanapalus, reclining on his huge bed and contemplating the extraordinary scene of carnage taking place around him [1]. Nude women press or lean against the bed in postures of despair or resignation. In the foreground the figures are life size. On the left a Negro stabs a white horse: on the right a bearded and exotically dressed man plunges a dagger into the throat of a writhing woman [2]. Heaps of precious objects, some apparently wrought of gold, and encrusted with jewels, and others made of silk and leather

1. Detail of *The Death of Sardanapalus*

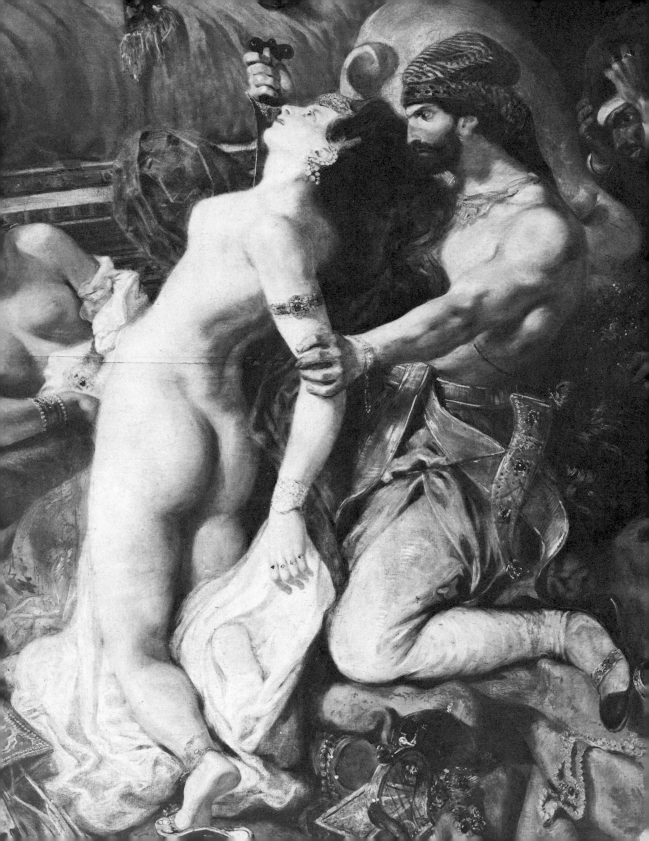

bedeck the foreground [3], while in the background the giant walls of a palace loom out of a darkness veiled with smoke and streaked with flashes of bright flame. The sumptuous colors (somewhat darkened by age, but visible in an oil sketch) spotted over the surface, echo the luxuriant pell-mell of objects, flicks of intense orange, yellow and red contrasting with cool grays and darks.

The rhetorical gesturing of the figures in the painting, who seem to be posing before an unseen audience, reminds one of the theatre, or even of the carefully choreographed movements of a ballet, and the dark background also seems rather more like a somber stage setting than a believably receding space, especially in view of its apparent

2 and 3. Details of
The Death of Sardanapalus

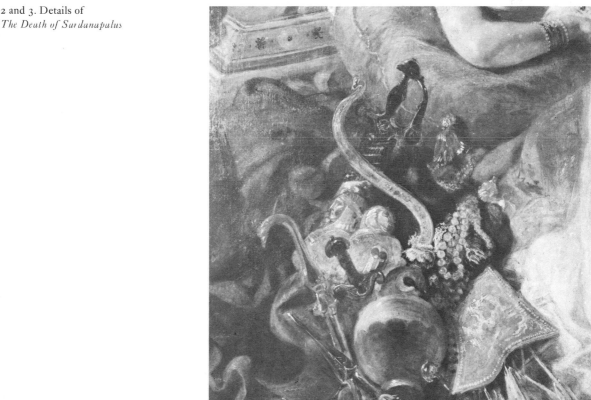

division from the brightly illuminated foreground, across which figures move like actors downstage under the spotlight.[2] We can in fact recognize in the work striking qualities which we associate with Romantic drama: constant and violent movement, color, expressions of terror and ferocity, and sensual impact. These qualities have given the work its great attraction for many spectators, but have also made it unpalatable to others whose taste required more coherence in the forms and space and less of the restless motion and conflict. The squeamish have found it especially hard to take the sadistic behavior unleashed in an erotic context, like the mangling of a lush bedroom scene by Boucher. The morbidity of a suicide accompanied by a massacre taints the vitality of the sensual, erotic forms and suggests a tension between the idea underlying the painting and the image (or formal means) utilized to represent it. One of the problems this book will attempt to solve is the relationship of this tension to the underlying themes of the painting, and its relation to the artist's own psychology.

In its obscure and troubling overtones produced by the disjunction of scale and significance (the king small, his menials large) and by the contrast between Sardanapalus' somber quiescence and the animated forms about him, the painting represents a consummate example of Romanticism, an extraordinary moment even within the passionate art of Delacroix. The unique power of the *Sardanapalus* tempts one to consider not only in what respects the work fits into the historical and cultural situation of Restoration France of the 1820s, and shares with other works belonging to the 'Romantic' era similar influences and traditions, but also in what respects it was uncommon both for the period and for the artist himself. In attempting to answer these and other questions, I will make considerable use of the artist's personal and intimate statements as recorded in his well-known *Journal* and *Correspondances* and also in his unpublished juvenile manuscripts at the Institut d'Art et d'Archéologie in Paris, which illuminate the psychology of the artist when he produced the painting. For it seems to me that

we can begin to fathom his unusual mind as it elaborated an exceptional work only through comprehending (within the framework of his epoch) the sources of his imagery in his motivations and his hopes, his fears and his joys.

In spite of certain later deviations from its text, it is clear that the inspiration for treating the theme came first from reading Byron's play *Sardanapalus* (1821). As Baron Charles Rivet remarked, 'while reading the barely legible drama by Lord Byron, he [Delacroix] had been struck by the picturesque side of its *dénouement*'.[3] The play ends with a climactic scene in which the Assyrian monarch terminates his life of debauchery by an heroic death. Realizing that his efforts to salvage his besieged empire in face of betrayal by his most trusted satraps had failed, Sardanapalus decided upon heroic joint suicide with his favorite concubine Myrrha, an Ionian slave, just as his enemies prepared to enter through a broken wall surrounding his palace. The defeated ruler had an enormous pyre built under his throne, and granted Myrrha the privilege of sharing his death and mingling her ashes with his. At the end of the play, off-stage, she lights the pyre with a torch and leaps into her lover's arms.

But it was the personality of Byron himself, notorious for his self-centered narcissism and sensuality no less than for his noble sentiments and self-sacrifice, which impressed his French audience and readers as much as the play. Byron seems to have strongly identified with his hero.[4] In the second canto of *Don Juan* (1819) he wrote:

> *How pleasant were the maxim (not quite new)*
> *'Eat, drink, and love, what can the rest avail us?'*
> *So said the royal sage Sardanapalus.* (stanza CCVII)

And when he began to write the play early in 1821 he recorded in his diary: 'Sketched the outline and Drams. Pers. of an intended tragedy of Sardanapalus, which I have for some time meditated. Took the names from Diodorus Siculus (I know the history of Sardanapalus, and have known it since I was twelve years old), and read over a passage in the ninth vol. octavo of Mitford's *Greece*, where he rather

vindicates the memory of the last of the Assyrians.' Like Byron himself, Sardanapalus was a complex personality. And, taking advantage of the ambiguities of his ancient sources, especially Diodorus Siculus' *Bibliothecae Historicae*,[5] Byron gave him positive qualities (which had generally been ignored) in addition to the idleness and dissoluteness for which Christian writers had held him up to censure.[6] Delacroix's painting parallels Byron's play in its innovative approach to the monarch, and displays him as meditative rather than fearful or stupefied amidst the mounting flames, and thus differs from almost all earlier versions of the scene.

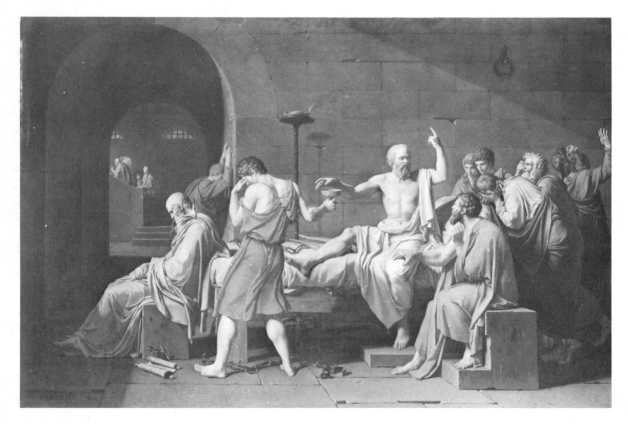

4. *The Death of Socrates*, 1787. J.-L. David

The disjunctive mood of the painting appears clearly in the contrasting scale of the figures, those in the foreground being at least life-size, those in the rear – including the main figure of the king himself – being much smaller. The deeply recessed position of Sardanapalus beside the servant bearing the cup of poison, is the opposite compositionally and morally to David's neoclassic Socrates, who in taking his poison orates to his disciples grouped frieze-like around him [4]. Unlike other major Romantic paintings such as Gros's *Battle of Eylau* (1807) or Delacroix's own *Dante and Virgil* of 1822 and *Massacre of Chios* [5], in which the main figures occupy

5. *The Massacre of Chios,* 1821–4. Delacroix

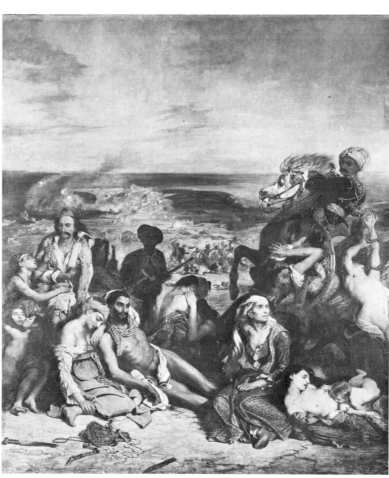

a foreground frieze, the *Sardanapalus'* space tilts diagonally back from the foreground, along the massive bed (a form comparable to the raft in Géricault's *Raft of the 'Medusa'* of 1819 [6]) towards the

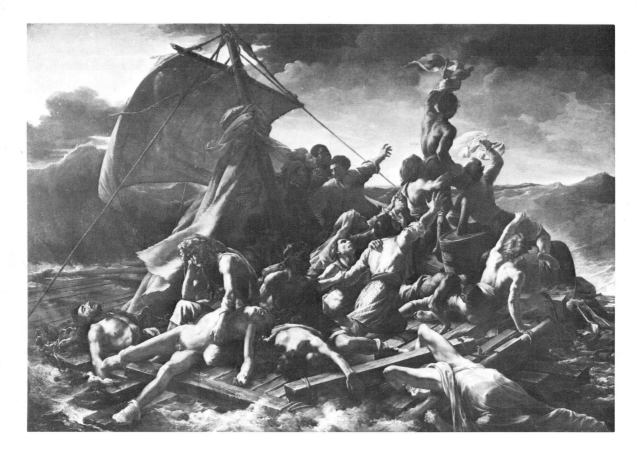

6. *The Raft of the 'Medusa',* 1819. Géricault

much smaller form of the king above. Moreover, David's famous Brutus in the painting of 1789 (Louvre), for all his brooding, poses like a statue fixed to a wall compared to the clouded introspection of Delacroix's reclining monarch. And even the despairing hero in the painting of 1799 by Delacroix's teacher, the neoclassical artist Guérin, *The Return of Marcus Sextus* (Louvre), exhibits fixed and clearly defined emotional 'contours' compared to the complex mood of the monarch. However, anticipations of certain aspects of the

Sardanapalus occur in the ambitious complexity of early Romantic compositions (Girodet, Gros, Géricault), and in Gros's suffering soldiers and their thaumaturgic Napoleon, as well as in Géricault's madmen and in his famous lithograph of a meditative figure seated beside a groom who struggles to subdue horses fighting in a stable.

The space within the painting has proved hard to decipher, and scholars do not agree on how to read it. The composition impressed Marcelle Wahl, who analysed its dynamic movements within a coherent space;[7] but Lee Johnson, emphasizing the character of bas-relief of the foreground figures, found a split between this planarity and the depth of the background. Lee Johnson[8] interpreted this as a conflict between the artist's tendency to retain neoclassical elements based on the taste and training of his youth, and his desire to use deep Baroque space conforming to his Romantic impulses.[9] He understood this conflict as an unresolved formal problem: as Delacroix matured artistically he improved, producing more coherent and harmonious solutions, which Johnson compares to those of the Post-Impressionists. Frank Trapp, sensitive to the special achievement of the painting, calls the space 'mannerist',[10] though without the strongly pejorative meaning of Lionello Venturi, who first applied the term to the *Sardanapalus*.[11] For my part, I feel that the split between foreground and background contributes to the picture's peculiar and disturbing power in displaying the opposed moods of pensive melancholy and animal energy, and of the detachment of the mental from the physical.

The complex composition contains unifying elements both in the subtle spiral movement (often overlooked) which passes from the foreground figures up toward the still eccentricity of Sardanapalus, attentive as a spider in his web, and in certain color repetitions not only in the pink flesh of the figures but in the accessories – in, for instance, the three important areas with golden objects: the horse's trappings to the left, the still life in the center, and the still life at the right. Pearls are also employed throughout the painting as a subtle unifier: under the foot of the slave stabbing the woman, decorating

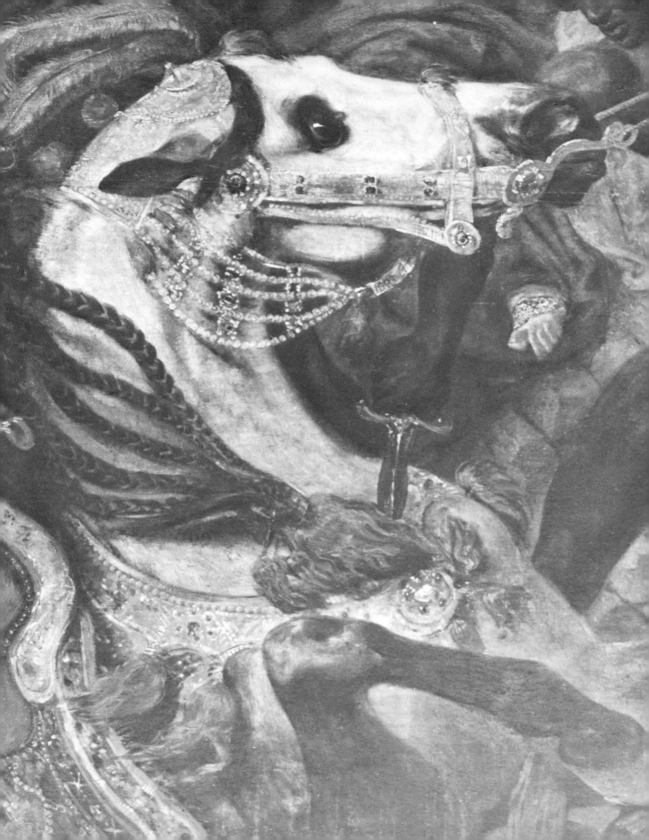

the quiver, on the horse's trappings [7], heaped beneath the elephant, and over the stake of the pyre. The inventively varied treatment employed by Delacroix in painting these pearls deserves close scrutiny.[12] The use of transparent glazes and thin scumblings and the varied handling of the shadows and highlights provides an effect of soft, rich coloring which suggests the pastel sketches the artist produced late in his development of the composition.[13] Apparently in his enthusiasm for new effects Delacroix went too far in some areas, and the painting deteriorated, later requiring restoration by his pupil Andrieu (under the master's supervision). The originality of Delacroix's treatment of these jewels [8] (and other accessories) becomes clear when one compares it to the handling of similar objects in other paintings also in the French painterly tradition; thus (to choose several works in the Louvre), in Boucher's *Diane sortant du bain* the pearls are like solid beads with uniform color and highlights [9], and in Gros's *Eylau*, like Géricault's *Cuiras-*

7 (*opposite*). Detail of
The Death of Sardanapalus

8. Detail of
The Death of Sardanapalus

9 (*far right*). Detail of
Diane sortant du bain,
1742. F. Boucher

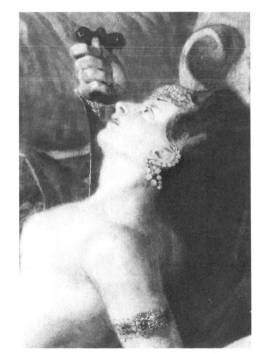

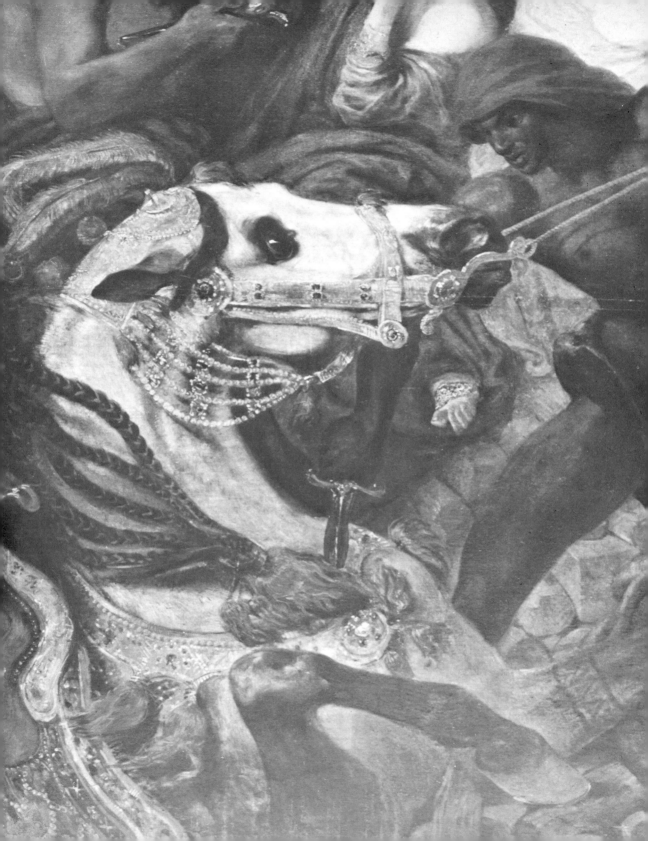

sier blessé and even like Delacroix's own earlier *Massacre of Chios*, the jewels are all solid and opaque, rendered in a rich impasto lacking the glazed (rather Venetian) transparency of those in the *Sardanapalus*.[14]

The color furnished by the drapery and the jewels is more than decorative, and actually serves a very important expressive function in suggesting blood and fire (a use of color later adopted and developed by Gustave Moreau). This transformation of the fire into colored materials minimizes the melodrama and description paraded by other artists and even in early sketches by Delacroix that still render the fire and smoke. Thus, the place where the sword enters the horse's chest shows not blood but its color equivalent, a red tassel [10]; the bright red cloth covered with jewelry replaces the fire and smoke indicated in an early sketch; the red tassels of the scabbard worn by the man stabbing the woman are flung in the air exactly over the wood of the pyre like flames; and a little higher a group of pearls in the shadows of the wood blocks suggests a dark, smoldering smoke. These changes, part of the careful elaboration of the composition, can best be followed in the evolution of the sketches for the painting.

10. Detail of *The Death of Sardanapalus*

2. The Sketches

In preparing his major paintings Delacroix rarely arrived at final
solutions to problems of form and expression without considerable
searching and groping. He has left us the record of those labours for
many paintings in the sketches he preserved.[15] The careful study of
the sketches for the *Sardanapalus* as they succeed one another in the

11. Sketch for *The Massacre
at Chios* (?), *c.* 1824. Delacroix

12 (*opposite*). Sketch for
The Death of Sardanapalus,
1827–8. Delacroix

development of Delacroix's thought should suggest important
features of the artist's working methods. Unfortunately, none of the
sketches bears a date, and so I have had to proceed intuitively,
arranging them on the assumption that the degree of finish and
chronological position are related in that the more tentative the
illustration of the subject, or the further from the specific details of
the finished work a given drawing is, the earlier it is, and contrari-
wise, the more the detailed resemblance to the final version, the
later.[16] On this basis the first sketch in the series would be illustra-

tion 12 with its divergent and uniformed suggestions, whereas the pastel study of a *babouche* [30], in its detailed resemblance to the painting belongs toward the very end of the series. The sequence of their illustration corresponds to the chronological order proposed.

The sketches for the painting include several of Delacroix's most powerful drawings, and some of his most beautiful pastels. But they are also of considerable interest for the glimpse they offer us into the artist's intentions, possibly even into his motivations, especially when their evolution can be related to the artist's personal life. The earliest sketch contains a hodge-podge of iconographic references, including Etruscans, Indians, Ethiopians and Nubians, 'Peintures

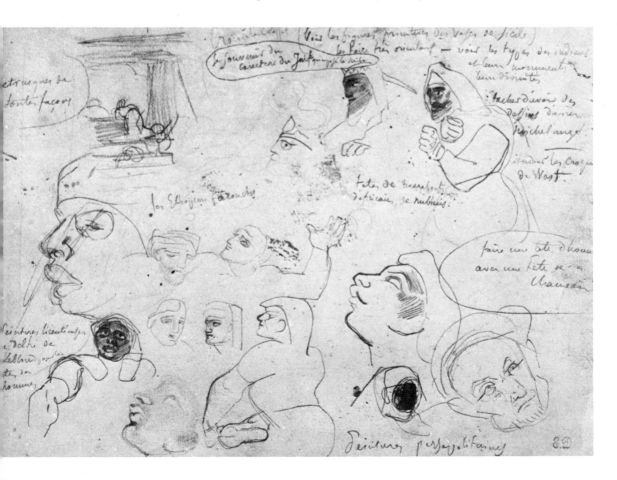

persepolitaines', Sicilian vase paintings, Jewish types, the sketches of Benjamin West (whose works he had seen in a London gallery in 1825), and the classic drawing of Michelangelo.[17] Although there

13. Sketch for *The Death of Sardanapalus*, 1827–8. Delacroix

14. Sketch for *The Death of Sardanapalus*, 1827–8. Delacroix

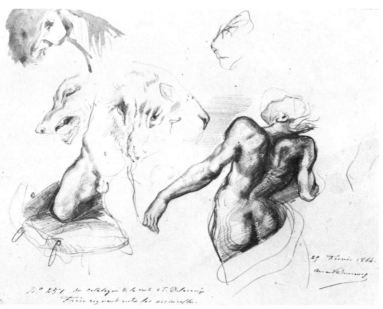

are no nudes on recto or verso, the allusion to the licentious paint-
ings of Delhi and the use of Italian (as we shall see presently) suggest
that the artist already associated voluptuousness with the painfully

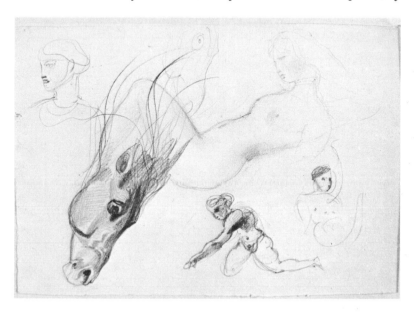

15. Sketch for *The Death of Sardanapalus*,
1827–8. Delacroix

16. Sketch for *The Death of Sardanapalus*,
1827–8. Delacroix

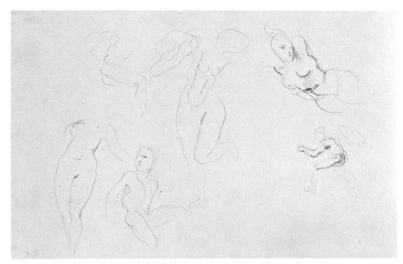

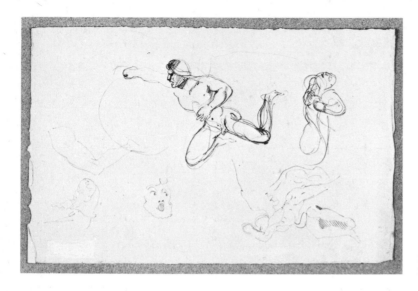

17. Sketch for *The Death of Sardanapalus*, 1827–8. Delacroix

18. Sketch for *The Death of Sardanapalus*, 1827–8. Delacroix

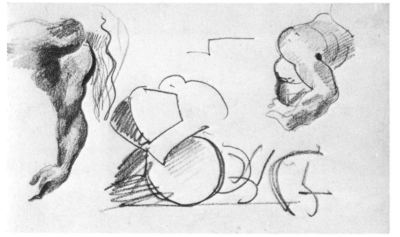

climactic scene, and that he understood Sardanapalus' approaching tranquillity (to which he alludes in an Italian phrase scribbled on the verso) through drinking the anodyne potion brought by a servant not in terms of philosophical detachment, but of a wished-for release of tension through sexual climax. That, during the 1820s he

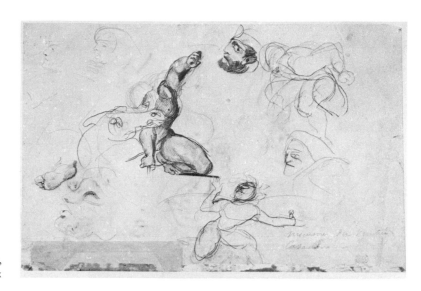

19. Sketch for *The Death of Sardanapalus*, 1827–8. Delacroix

sometimes viewed Sardanapalus' position, reclining with his hand to his head, as more sexual than philosophic becomes clear in a sketch dated about 1824 [11], showing a voluptuous nude woman reclining on a pillow like Sardanapalus, head on hand, and next to her a provocatively stretching nude and a copulating couple.

All of the figures in Delacroix's sketches are strong and beautiful, and in the early drawings we see powerful, athletic males such as the Negro in the foreground, and the lovely harem girls being slaughtered. These figures have a Michelangelesque or perhaps even a neoclassical character (there is none of the pathetic realism of the aged woman in *Massacre of Chios*), and some groups resemble neoclassical bas-reliefs, especially those in the Princeton drawing [20], which reminds one of David's *Death of Socrates* of 1787. Despite the Baroque energies in this drawing of the figure to the left which crowds in, and of the writhing form in the center, we wonder just how romantic Delacroix's intention was. The Romantic aspect would become clear, in fact, were one to compare the preparatory drawings by Delacroix with those by artists such as David, who

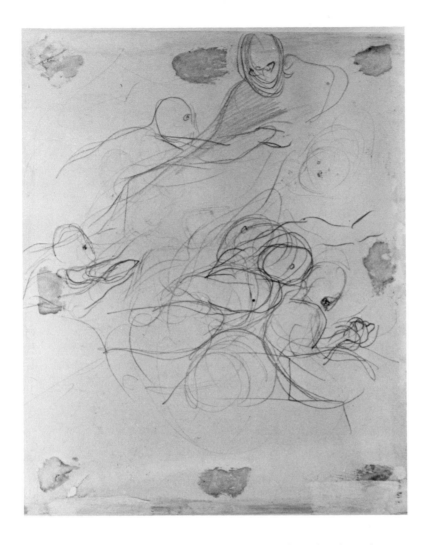

rarely departed from the 'business' of the sketch, whereas Delacroix's occasional scribbles often contain flights which seem only quite remotely related to the subject at hand.

In drastically varying the positions as well as the poses of some figures, Delacroix displays his powerful urge to seek out new solutions; for example, the shift of the stabbing man and his victim from the bed down to the foreground [23], to correspond to the stabbing of the horse, a parallel perhaps visible in another sketch

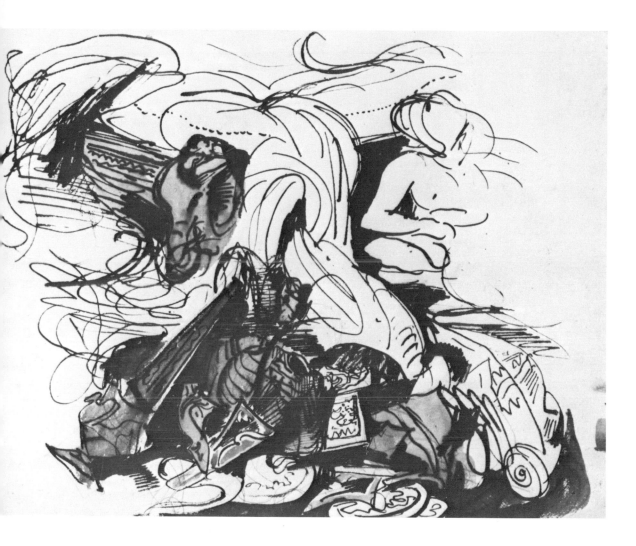

probably for the painting, and presenting a woman with a necklace
and a terrified horse as victims [15]. The bed itself undergoes
remarkable changes as Delacroix's highly personal imagery realizes
itself: first its almost rude simplicity becomes elaborated with the
addition of the elephant head at the corner [24]; and then in a
sketch [21] (painted about the same time) the critical change occurs
that emphasizes the dynamic quality of inanimate objects such as
the garments and bed-sheets that in fact flow down, spilling into the

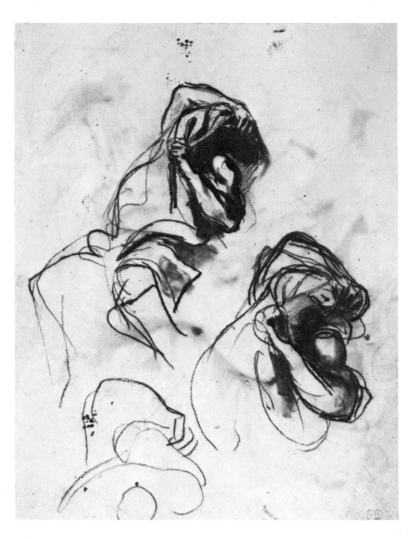

22. Sketch for *The Death of Sardanapalus*, 1827–8. Delacroix

foreground jewelry. With a truly Rubensian flair, Delacroix uses drapery as a dramatic element to cover or uncover [22], to be pushed, bunched or stretched (one thinks of his painting of Othello suffocating Desdemona with her bed-sheet). The elephant clearly functions dynamically to funnel the energy of the bed down toward the cluster of jewelry heaped on the foreground. Apart from these larger, more obvious elements of the picture, Delacroix explored

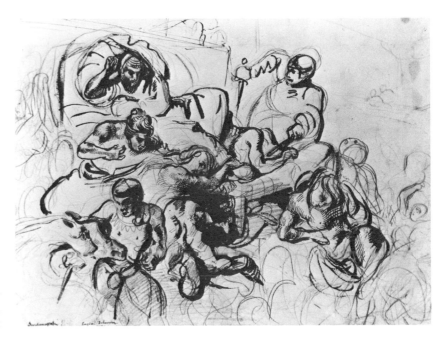

23. Sketch for
The Death of Sardanapalus,
1827–8. Delacroix

24. Sketch for
The Death of Sardanapalus,
1827–8. Delacroix

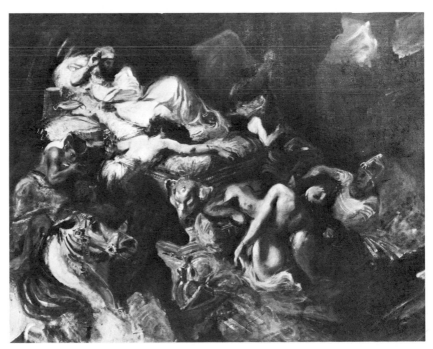

24A. Detail of 24

25. Sketch for *The Death of Sardanapalus*,
1827–8. Delacroix

26. Sketch for *The Death of Sardanapalus*,
1827–8. Delacroix

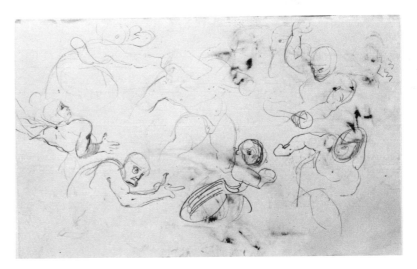

his hero's physiognomy, which he varied from an expression as
fierce as that of his Arab horsemen to the complex aloofness
('tranquillity') of the final version.

In studying these changes we discover, I think, two opposed ten-
dencies: a heightening of the emotional intensity of the scene to
the point of horror (in the hanging of Aischeh), and a refinement
of sensuous details, as in the three late pastel studies of nudes

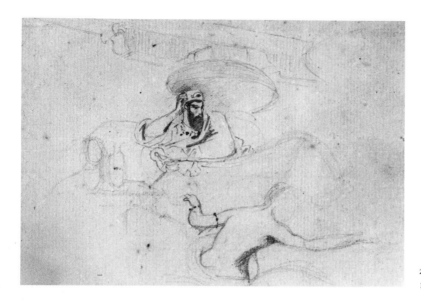

27. Sketch for *The Death of Sardanapalus*, 1827–8. Delacroix

28. Sketch for *The Death of Sardanapalus*, 1827–8. Delacroix

28A (*opposite*). Detail of 28

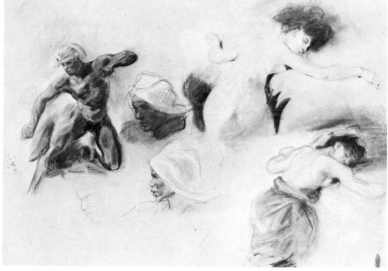

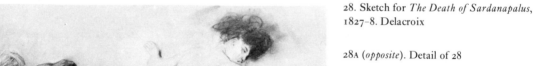

[28, 28A, 29]. One also notes that in these pastels the artist tried out various solutions to the decorative and compositional problems. He sketched the Negro's turban as a light object, contrasting strongly with his dark skin, but in the painting he made the turban as dark as

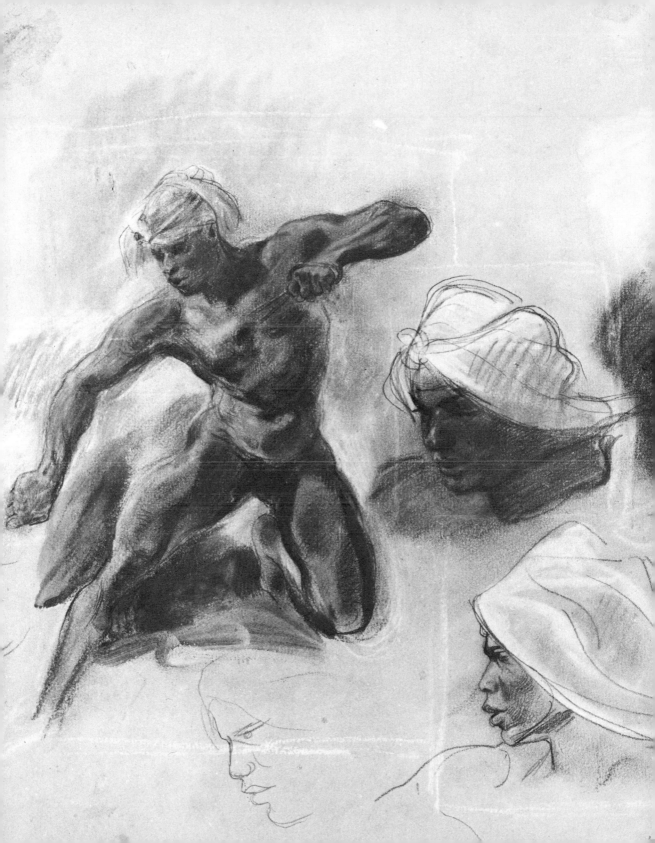

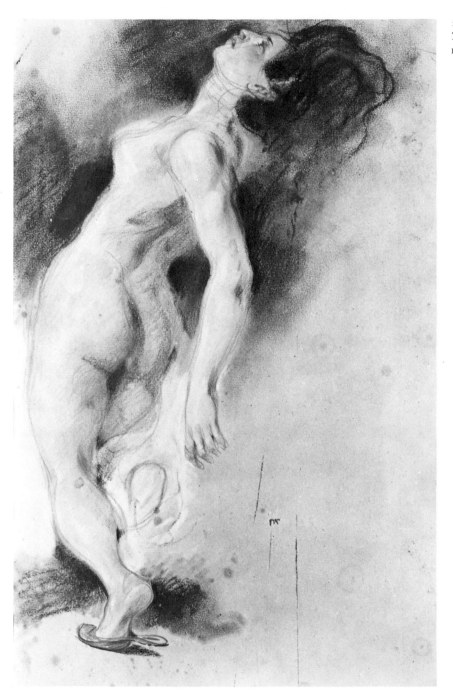

29. Sketch for
The Death of Sardanapalus,
1827–8. Delacroix

30. Sketch for
The Death of Sardanapalus,
1827–8. Delacroix

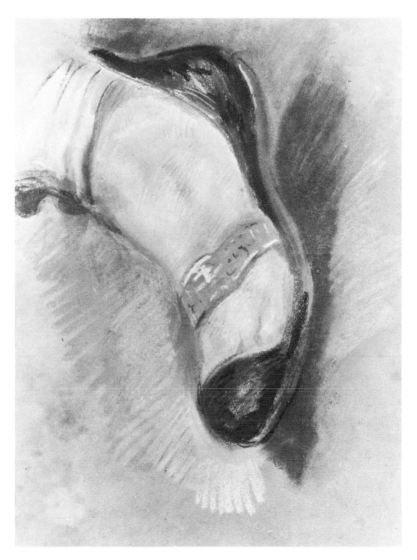

the whole figure, probably as a contrast to the illuminated shoulder of the dark-haired nude above him. And in his famous sketch of the *babouche* [30], he used a hatching technique to achieve brilliant effects which he was still unable to equal in painting.[18]

Delacroix's efforts at mastery of the formal means of his art eventually ripened into the technique employed in his *reprise* of

1844 in the McIlhenny Collection [56]. This work is looser and sketchier than the Salon painting, and shows more clearly the basic movements within the composition – the area between the Negro's right leg and the nude's robe is blocked off in a series of square forms tracing a path of motion; the smear of flames added over the elephant's head at the right serves to link the raised arm of the man at the extreme right and the bent arm of the nude on the bed; and the elephants unambiguously display their function as dynamic extensions of the bed. An instructive comparison can be made between the 'sketchiness' of this work and that of the oil 'sketch' [24]. In the latter, red accents, distributed on the horse's bridle, on the turban of the slave, on the bed, and over some figures and their garments, serve as *liaisons*, which are later replaced by jewelry such as the strings of pearls in the horse's bridle.[19] While the earlier sketch, like the *reprise*, has a rapid execution, with little attention to small details, the latter seems a more completely realized work in containing, like the finished painting, many more transitional passages, carefully considered formal means to unify the picture, and a better grasp of abstract formal and color aspects. Imagining the grotesque pantomimes of sexual passion realized so clearly in the tormented nudes of the finished painting, Delacroix may well have found himself irritated by what one might call an 'internal voyeurism'. The artist in part relieved this tension, it seems to me, through the climactic realization of painting, which provided an outlet progressively more available to him as he developed the formal side of his art. Thus, in the *reprise* there is a less detailed description than in the finished painting, while the color relations and the dramatic movement of form are emphasized.

This transfer of emphasis from the dramatic to the aesthetic indicates perhaps personal changes in the artist culminating in his ability to 'sublimate' more of the erotic energy of his youth into the sphere of formal and coloristic pattern. This is in keeping with the color notes he made for the painting, in which he speculated about ways to realize the flesh and drapery of the nudes, but mainly as

functions of their color relation to the rest of the painting, rather than as isolated sensual detail. One glimpses something of Delacroix's technique for the original painting in that of the *reprise*, according to his helper Andrieu, as cited in Appendix 2. Delacroix's color notes for the *reprise*,[20] are especially valuable and relevant, including as they do all the colors demanded by the artist from his dealer, M. Haro, for the Salon painting ('6 vessies de blanc de plomb, 6 de jaune de Naples, 2 d'ocre jaune, 2 de cobalt, 2 de noir de pêche, le tout plus liquide que les couleurs que l'on prépare pour tout le monde').[21] The notes for the *reprise* are as follows: 'Linge de la femme sur le devant: sur un ton local *gris blanc*, *terre de Cassel* ou *noir de pêche*, etc. – Ombres avec *bitume, cobalt, blanc* et *ocre d'or*. Base de la demi-teinte des chairs, *terre de Cassel* et *blanc*. Demi-teinte jaune de la chaire, *ocre et vert émeraude*. Ajouter aux tons d'ombre habituels de la palette: *Vermillon* et *ocre d'or* . . . Ebaucher les chairs *dans l'ombre* avec tons chauds, tels que *terre Sienne brûlée, laque jaune* et *jaune indien*, et revenir avec des *verts*, tels que *ocre* et *vert émeraude*. De même les clairs avec tons chauds, *ocre et blanc, vermillon, laque jaune*, etc.; et revenir avec des *violets* tels que *terre de Cassel* et *blanc, laque brûlée* et *blanc. Ne pas craindre*, quand le ton de chair est devenu trop blanc pour l'addition de tons froids, *de remettre franchement les tons chauds du dessous*, pour les mêler de nouveau.'[22]

The innovative elements in Delacroix's sketches for the *Sardanapalus* contributed to an iconography which seems very subjective when compared to the more literal illustrations of the neoclassics. The simultaneous refinement of the beautiful and the horrible as the sketches evolved, and the expansive, integrative, flowing Rubensian movements displayed in them sharply contrasts with the more prosaic, isolating studies of a David. While neoclassic sketches tend to refine on a preconceived plan progressively sharpened and crystallized in a series of sketches, Delacroix, who at times also deliberately worked out his compositions (especially for his later big murals), departed from the neoclassics in accepting his

occasional '*trouvailles*', chance intrusions upon his mind that changed the treatment of the color or form of the work, or radically modified its subject. In this respect Delacroix goes far beyond even such original spirits as Gros and Géricault, for whom personal fantasy did not break through the compositional and iconographic restraints to the degree evident in the *Sardanapalus*.

3. The Sources

The history of the Sardanapalus theme serves to reveal the originality of both Byron and Delacroix. In the West, the story of Sardanapalus, who lived presumably in the seventh century B.C., was known already in antiquity, the Greeks receiving the story chiefly through the accounts of Ctesias, a Greek physician at the court of Artaxerxes Mnemon. Ctesias' book, written at the very beginning of the fourth century, the *Persica*, presents Sardanapalus as a passive voluptuary, responsible for his own downfall. Emphasis on his depravity was probably derived from Alexander's discovery in his expeditions to Asia of the epitaph on the tomb of Sardanapalus: 'I have eaten, drunk and amused myself, and I have always considered everything worth no more than a fillip.' Aristotle doubtless heard of it through his former pupil Alexander and – in a manner allied to his criticism of self-indulgence in the *Nicomachean Ethics*[23] – commented caustically: 'An epithet worthier of a pig than a man.' The Romans continued the Greek estimate of Sardanapalus, to judge from Cicero's quotation of Aristotle's comment, from Ovid's use of Ctesias' account in the first century A.D.,[24] and from Juvenal's verse in the early second century A.D. referring to the featherbed (*pluma*) of Sardanapalus.

Representations of Sardanapalus in Greek sculpture, so far as I can find, ignore the death scene and simply represent him as a draped standing figure (as in a statue of 360 B.C. in the British Museum), sometimes with the voluptuous qualities of a Dionysus. The borderline between Bacchus and Sardanapalus was so vague, in fact, that the identification of this statue could still occasion considerable discussion in the early nineteenth century by Visconti, who explained 'how the name of Sardanapalus came to be inscribed on an idol that does not represent this king of Assyria, whose name has

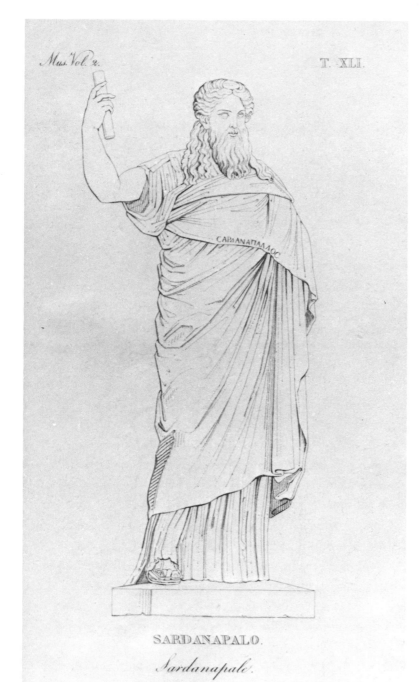

Mus. Vol. 2. T. XLI.

ΣΑΡΔΑΝΑΠΑΛΛΟΣ

SARDANAPALO.

Sardanapale.

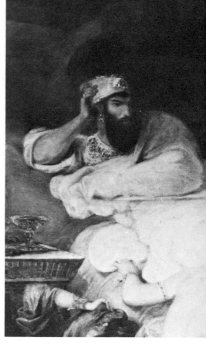

31. 'Sardanapalus'.
An engraving of an antique statue

32 (*above*). Detail of
The Death of Sardanapalus

almost become synonymous with voluptuous and effeminate character'. He notes that it is 'precisely the character that the ancients gave to Bacchus, especially when he was, as in our idol, represented bearded and dressed in the tunic called *bassaride*'.[25] While Delacroix probably never saw this statue, he may very well have known Visconti's engraving after it [31] showing the bearded king in his *bassaride* with one arm exposed and one covered as in the painting [32].

Inevitably, Christians for whom the art of dying (*ars moriendi*) meant a spiritual triumph over death, moralized severely against the old voluptuary's materialist self-indulgence down to the last moment. Following the judgments of Aristotle and Cicero, St Augustine in Chapter 20 of his *City of God* railed against the debauchery implied by Sardanapalus' epitaph. In a tradition which surely goes back earlier, we find a Byzantine illustration of Sardanapalus' death [33] in *The Miniatures of the Chronicle of Manasse* of *c.* twelfth century A.D.[26] While few if any other Byzantine examples seem to have survived, such motifs were copied uni-

33. *The Death of Sardanapalus,* *c.* twelfth century

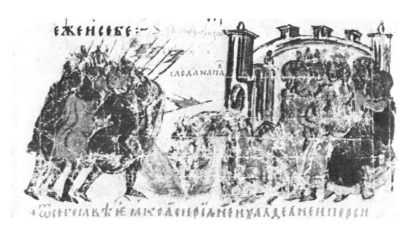

versally in popular chronicles, and presumably provided a vehicle for continuing the tradition down to the Renaissance. The *Chronicle* describes Sardanapalus as a belly-worshipper,[27] a libertine and a lover of women, who smeared his face with ointments and was gener-

ally effeminate. In the center of the miniature appears the name Sardanapalus in Cyrillic characters, and on the right the beardless, long-haired king himself seated on a throne amidst women, raising a long-stemmed glass in his right hand. The left half of the miniature corresponds to the tale of the revolt of Arbaces, the attack of the Chaldeans, the defeat of King Sardanapalus' troops and his own suicide on a pyre. A group of soldiers on the left approaches with raised spears and flags, facing threateningly to the right, toward the palace of Sardanapalus. At the center a great pyre has been kindled, into which the king casts himself.

Literary treatments from the Renaissance to the Romantics generally continued to draw an admonitory example from Sardana-palus' luxurious life leading to a cowardly death. But in the four-teenth century Boccaccio exceptionally recounts in his *Fates of Illustrious Men* (Book II) that Sardanapalus, after a life of indo-lence and luxury, seeing the end of his power approach 'woke up at last and, preferring death to slavery, built a pyre in his great hall. First, he threw all his precious goods on it, then mounted it him-self... He died like a man.' During the fifteenth century in Germany the Alsatian Sebastian Brant's *Ship of Fools* emphasized the sensual proclivities of Sardanapalus, and alluded to his famous featherbed; while in Italy Filarete's famous *Treatise on Architecture* (1460) refers to him as 'the inventor of the featherbed'.[28] In France during the sixteenth century the image of Sardanapalus as the epitome of voluptuous living became commonplace, to judge from the pe-jorative epithets derived from his name:[29] 'Sardanapalien', 'Sarda-napalesque', 'Sardanapaliste'. The luxurious life of Sardanapalus, without the homily implied by the accompanying death (as in the *Chronicle of Manasse*) was emphasized in the sixteenth century by the Flemish engraver Jean Théodore de Bry [34], who showed the monarch in the bath, surrounded by rich ornamentation and gro-tesques on a dark background within a roundel.[30] I have seen nothing in the way of painting, and know of only one work based on the monarch's life in the seventeenth century, although we can presume

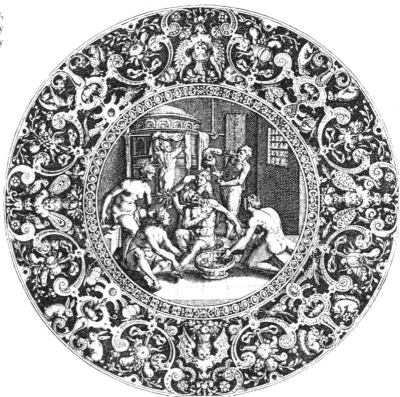

34. *Sardanapalus*,
sixteenth century. An engraving by
Jean Théodore de Bry

that the common usage in the sixteenth century gave rise to some examples. Histories of Persia, such as Petro Bizaro's of 1601, referred as usual to the effeminate character of Sardanapalus, which he associates with the defeat of his nation.[31] In the eighteenth century a considerable number of French painters drew subjects from Diodorus, but none seems to have illustrated his account of Sardanapalus.[32] The proverbial '*pluma Sardanapali*' of Juvenal's verse is however mentioned by Lord Shaftesbury in England. It is in the nineteenth century that Sardanapalus again comes into his own, but now with a new estimate of his character accompanying the old one, still maintained in such works as the essay of Wopko Cnoop Koopmans.[33] The more positive – and unmoralizing – attitude toward Sardanapalus seems to have been initiated in the nineteenth century by Byron's play of 1821, which presented him as a man

capable of moments of philosophic depth and of a devil-may-care heroism absent in the earlier images of depravity. Given the prodigal character created by Byron, we are not surprised to learn from Paul Robert's *Dictionnaire aphoristique . . . de la langue française* that 'Sardanapalesque' was in vogue during the Restoration along with such words as 'pyramidal' and 'babylonien' as expressions of hyperbole. As an addendum to earlier praise or blame of the monarch's end, the post-Symbolist poet Charles Cros in *Le Collier des Griffes* (1908), admiring Sardanapalus' luxuriant mode of life, merely expressed regret at its loss: 'Sardanapale avait d'énormes richesses, un peuple dompté,/Des femmes aux plus belles formes,/Et son empire est emporté!'

The melodramatic possibilities of the story seem to have been best suited to musical interpretations, and we find Byron's play, right up to its *dénouement* of suicide, the basis for a number of versions in France and Italy. In 1830 the Institut in Paris gave out as a subject for a cantata (probably inspired by Byron) 'La dernière nuit de Sardanapale'. The first prize was won by Berlioz, who wrote, 'Le poème finissait au moment où Sardanapale vaincu appelle ses plus belles esclaves et monte avec elles sur le bûcher. L'idée m'était venue tout d'abord d'écrire une sorte de symphonie descriptive de l'incendie, des cris de ces femmes mal résignées . . . et du fracas de l'écroulement du palais.' Berlioz's climactic fire, which he smuggled into the performance of his work *after* the jury had judged it, made a big impact on his contemporaries.[34] Giulio Litta wrote the vocal score for Pietro Rotondi's 'melodrama' *Sardanapalo*, performed in September 1844. Henri Becque's *Sardanapale*, set to music by Victorin Joncière, was published in Paris in 1867, and ends with a word-play on 'la mort' and 'l'amour' delivered before the funeral-pyre: '. . . aimons encore dans les bras de la mort.' P.Cav. Taglione choreographed a version – *Sardanapalo, Re d'Assiria* – with the music of Hertel, performed at La Scala, Milan, in 1867, whose final scene '*Morte di Sardanapalo*', makes use of all the sentimental clichés the scene could offer: after mounting the burning

pyre and drinking together from the cup of poison, the lovers raise
'their arms for a final embrace, and exchange their last kiss'. Finally,
Pierre Berton wrote a *Sardanapale* (*d'après Byron*) with the music
of Alphonse Duvernoy, published in Paris in 1882, which ends:
'La foule des rebelles se précipite en scène et vient s'arrêter au bord
du bûcher où Sardanapale et Myrrha disparaissent dans les flammes.'

Like the dramatic and musical versions, nineteenth-century
paintings illustrating the theme of Sardanapalus' death follow
Byron and shun the frightful massacre introduced by Delacroix
(except for copies of Delacroix's painting by his pupil Andrieu and
by Fr. Villot). The engraving by Cruikshank illustrating *The Self-
Destruction of Sardanapalus* for George Clinton's *Memoirs of the
Life and Writings of Lord Byron* (London, 1825), shows the bearded
monarch on his throne set over faggots, while below him Myrrha,
holding a smoking torch 'fires the pile' [35]. A later moment –
Myrrha sitting beside the king and exclaiming 'la flamme s'élève' –
was chosen by Achille Devéria for his rather conventional engraving

35. *The Self-Destruction
of Sardanapalus*, 1825.
An engraving by George Cruikshank

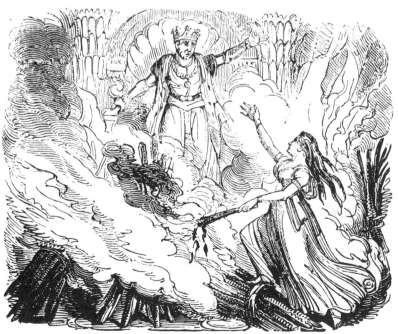

36. *The Death of Sardanapalus*,
1825. Achille Devéria

published in January 1825 in the French edition of Byron [36]. The
big painting by John Martin, *The Fall of Nineveh* of 1827–8 [37],
and so exactly contemporary with the Delacroix,[35] illustrates (in the
artist's words) 'the moment . . . in which Sardanapalus, with his
concubines, is going to the pile . . . for his and their final destruction'
and weakens the impact of their death – in contrast to the compelling
intimacy of Delacroix's treatment – by limiting the scene to a small
part of a large canvas charged with events. Francisco Lameyer's
(1825–77) oil painting [38] shows the frontally seated figure of

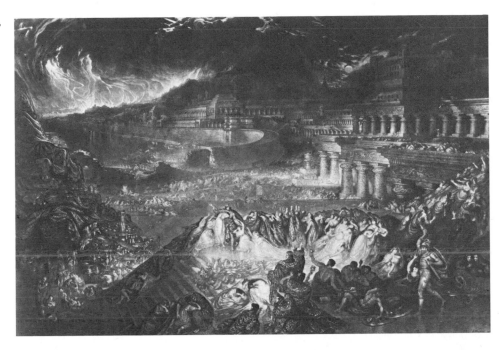

37. *The Fall of Nineveh*,
1827–8. John Martin

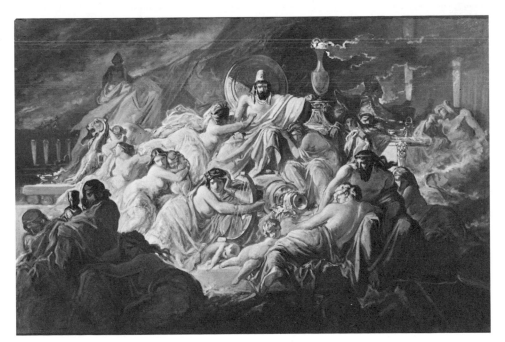

38. *The Death
of Sardanapalus*, 1860s.
Francisco Lameyer
y Berenguer

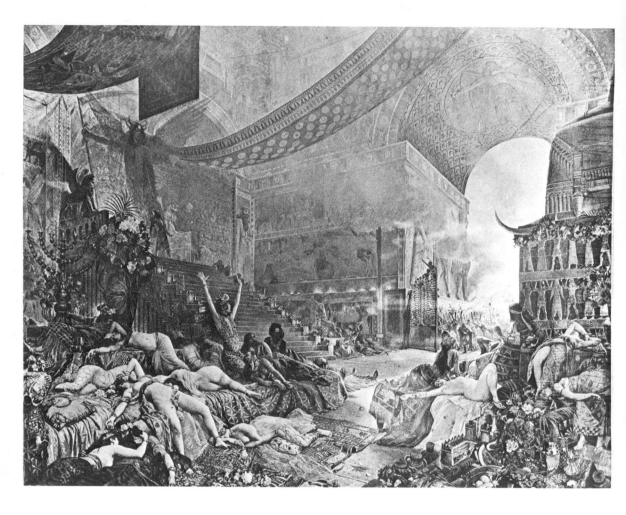

Sardanapalus almost lost among the swarming figures and smoke. And Georges Antoine Rochegrosse (1859–1938) painted a tame *Bûcher de Sardanapale* once owned by Delacroix's friend Auguste Constantin, as well as a more spectacular *Last Days of Babylon* [39].

Possibly the one instance of a great painting which has been touched by the mood and spirit of Delacroix's *Sardanapalus* might be Cézanne's *A Modern Olympia* [40]. This point requires some demonstration because of obvious differences between the two

39. *The Last Days of Babylon*, 1892. Georges Antoine Rochegrosse

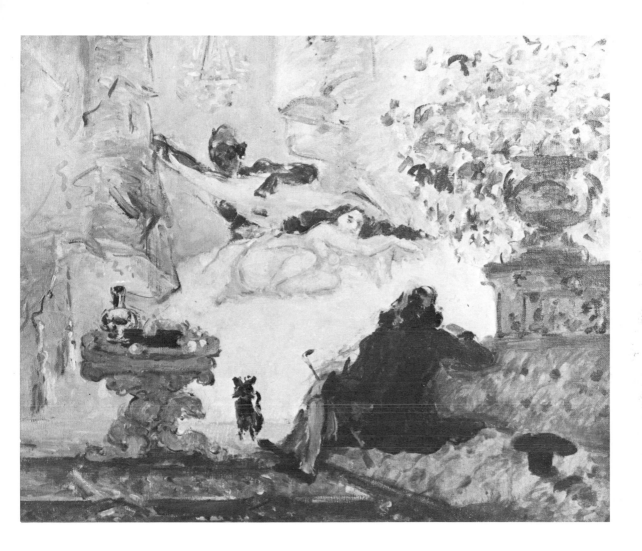

40. *A Modern Olympia*,
1872–3. Cézanne

works. Cézanne made studies of the figure of Sardanapalus and of the slave stabbing the horse in Delacroix's painting as early as 1866–7.[36] The latter figure belongs with the mood of *The Rape* of 1867, and *The Wine Grog* (or *Afternoon in Naples*) of 1866–7, both examples of the artist's obsessive eroticism, which he was later to transform (or sublimate). Like the later Delacroix, Cézanne, after a tortured youth when he produced an intensely expressive art, arrived at a masterly style at once restrained (structured) and subtly

lyrical or expressive in character. A turning point in this development may well have been the *Modern Olympia*, in which the imaginative world of the artist's dream confronts the sexual temptation and reality of the nude model as presented in Manet's *Olympia* of 1863. The fantastic element in Cézanne's painting that alienated Manet has affiliations with Delacroix's Romanticism. Essential elements were probably suggested by the *Sardanapalus*: the diagonal composition with a prominent central bed occurs in both paintings. The posture of Cézanne's black servant removing the drape from the blond nude strongly resembles the Negro slave's in the *Sardanapalus*; and the seated contemplating figure of the man with his back to us probably caricatures Manet's reclining gentleman in *Le Déjeuner sur l'herbe*, but also suggests an ironic reversed image of the artist as a reclining Sardanapalus (we are one step from Picasso's burlesque sketch of 1905 inverting the roles, with the Negress on the bed served by the artist). It was precisely in 1873 that Durand-Ruel, whom Cézanne knew, bought the *Sardanapalus*, and that year an illustration of the painting was published as part of the catalogue of the Galerie Durand-Ruel with preface by Armand Silvestre (vol. II, pl. CCXLVII). In re-creating the emotional and stylistic tensions of the great Romantic work in his own terms Cézanne may well have produced the best tribute to its undimmed glory.

4. Byronic Romanticism

Delacroix's painting (as already noted) – especially in its approach to the king – clearly stands among the Romantic works indebted to Byron's play. The most significant aspect of Byron's conception of the character of Sardanapalus, and the one most important for Delacroix's interpretation, was probably his transformation of the monarch into a bourgeois dandy, a fashionable and elegant gentleman contemptuous of morality and lightly self-indulgent. This blend of nobleman and bourgeois in Byron's hero reflected the complex mood of those young middle-class artists and writers who, regarding themselves as aristocrats of art, emulated the manners of the *ancien régime*. Curiously, this escape to older models of nobility came to signify by the mid-twenties a real rebellion against the sterility and repression of the Bourbons with whom young Romantics at first had identified.

The dandy's superior and distant attitude (like the mood of art-for-art's sake) represents an evolution from the dramatic terrors and excesses which Romantics had earlier displayed in face of their anxieties. After the turn of the century, the deluge theme, the fusion of man in Nature, the sexual orgy and in general the immersion of the individual in the mass became almost commonplace for Romantic painters and writers (John Martin, whose tiny Sardanapalus is lost in a colossal stage setting, painted a *Deluge* on the same scale at the same period). Another attitude, at once opposed to and allied to the first, emphasized the isolation and uniqueness of the genius in the face of an alien and unsympathetic world, which he tried unsuccessfully to engulf like a beaten Napoleon bound to end at his private St Helena. It is this last attitude that persists as late as

1858 in the blasé character described by Gautier, and which so resembles Sardanapalus:[37] 'Les satiétés de la jouissance, le blasement des volontés satisfaites aussitôt qu'exprimées, l'isolement du demidieu qui n'a pas de semblables parmi les mortels, le dégoût des adorations et comme l'ennui du triomphe avaient figé à jamais cette physionomie, implacablement douce et d'une sérénité granitique.' One step more and we will reach the Baudelairean dandy, coolly poised at the precipice of his own mystery.

In keeping with his dandyish character, Sardanapalus, just before going to battle, like a true 'fashionable', asks first for a mirror to see whether the armor suits him: 'This cuirass fits one well . . . Methinks, I seem / Passing well in these toys; and now to prove them.' (Act III, Scene 1.) Byron, too, scorned the common herd, and vaunted the manners of the lord he was. But he refused to submit to the code of his aristocratic class or of any other; for his great theme was intellectual and moral freedom, reflected negatively in his affectations and mannerisms, and positively in his imaginative flights and spiritual independence. In the Europe of the 1820s dominated by the absolutist ideas of the Holy Alliance, Byron's revolt against the establishment easily became a model among French youth, constrained by the narrow-minded society of the Bourbon Restoration. In fact, the expression in Byron's writings of a friction with his own government and with his fellow-countrymen, and his broadly cosmopolitan outlook, inspired many young rebels to a self-imposed exile, either real (expatriation to Greece or the Near East) or symbolic (rejection of contemporary European culture in favor of remote places or periods). Within this context it is quite possible that Delacroix's *Marino Faliero* of 1827, borrowed from a scene in Byron's play depicting the fall of a despotic ruler, was a cryptic reference to the unpopularity of Bourbon rule.[38] Certainly the restlessness and preoccupation with death on the part of the Romantic artists signified a discontent with the existing order of things which was distasteful to the ruling caste. It is little

wonder that the epitome of that *malaise*, the *Sardanapalus*, a work exhibiting suicide, sadism, Oriental despotism and sensuality should have received no official recognition, and much abuse from the academic critics. (On the other hand, its lack of a positive revolutionary message deprived the painting of the propagandistic value once served, for example, by David's art.) The dandy's rejection of a materialist society, and his concentration of all social values into art characterizes the art-for-art's sake movement led by Gautier, who wrote that for the hero of his book *Fortunio* (1838), 'one of his greatest pleasures was to mingle barbarity and civilization, to be at once a satrap and a "fashionable", Brummell and Sardanapalus.'[39] It is the politically uninvolved aspect of the Byronic hero, disdainful of the world, suffering under a malediction, living in solitude and with 'noble melancholy' that passed into Gautier's movement and into Nodier's 'école frénétique'.[40] Delacroix's bearded Assyrian king Sardanapalus conforms well to the two generations of bearded Romantics or *barbus* known to Nodier,[41] one lasting from 1799 to 1803, the other from 1827 to 1832.

The inspiration for the theme of Delacroix's *Sardanapalus* is just one aspect of an influence which extended to the personality of Delacroix himself, especially during the 1820s, when Byron was most popular in France. As G. H. Hamilton has observed:[42] '. . . the Byronic element in the personality of Delacroix . . . is apparent throughout these first years of the *Journal*' (begun in the early 1820s). Hamilton finds parallels between the introspection of Byron's amatory verse and Delacroix's entries in his *Journal* despairing at his inability to recapture the happiness of the day before, and shows how both men made subjective analyses of their states of mind and expressed disillusion over their successes. Although the artist really did have objective difficulties in terms of money and health, Hamilton finds a large residue of Byronic self-centering evident in the youthful writings, and observes that Delacroix was especially interested in 'the identity of thought and

action in Byron's life and poetry'. Delacroix seems often at that time to have dreamed of a career in writing, and to have envied Byron his medium of poetry, although later he was to overcome his fascination with the poet, and to regard it as an adolescent phase of his development.

The haughty and chill isolation of Sardanapalus in Delacroix's painting as in Byron's play is typical of the individualistic mood of Romanticism in the 1820s. Stendhal's *Pensées* reveal a disdain for the average person that he refused to display frankly in public, and Alfred de Vigny, in a letter to Victor Hugo of February 1823, uses the Horatian phrase '*profanum vulgus*', a contemptuous reference to non-artists, those not initiated into the service of the Muses. The image of the melancholy poet as a genius misunderstood among his followers – with Tasso as the prime example – was defined for the Romantics by the Swiss writer Sismondi in his *De la littérature du midi de l'Europe* of 1813.

This attitude of proud isolation was already deeply ingrained in the young Delacroix's thinking – he used the *profanum vulgus* phrase already in his early school notebooks dating to his fifteenth and sixteenth years, and late in life he noted in his *Journal* (14 July 1850) that most men lead mechanical lives but 'since they don't understand the life of the mind, they don't feel they're missing anything . . . they are closer to the animal than to man'. The theme of the great man or the genius alone amidst the unaware crowd always haunted him and was to be expressed poignantly during his maturity in such works as the *Christ on the Sea of Galilee* [41] with Christ asleep in the storm-tossed boat while the panicky sailors struggle for life; in the *Christ on the Way to Calvary* (1859) with Christ mocked by the crowd while he carries his cross; and in *Michelangelo in His Studio* [42], an interpretation of the Renaissance genius as a Byronic hero plunged into despair in the midst of his untouched and incomplete creations. A sympathy with Michelangelo moved Delacroix to write in 1830,[43] 'Michelangelo unemployed, having no positive demands and a firm objective for his

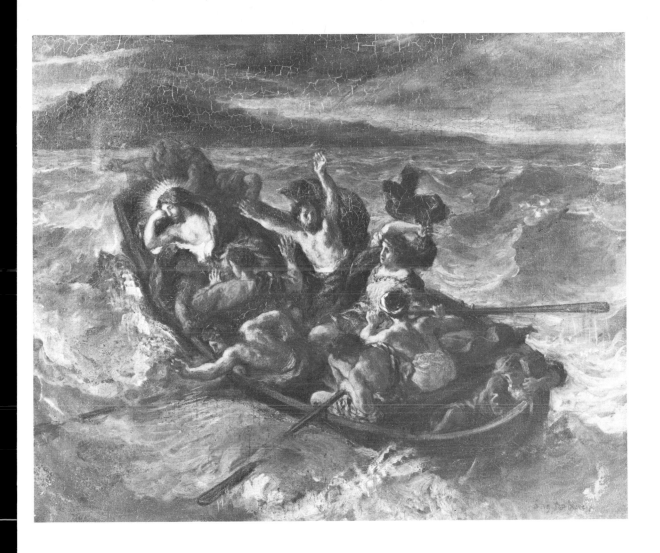

41. *Christ on the Sea of Galilee*, 1854. Delacroix

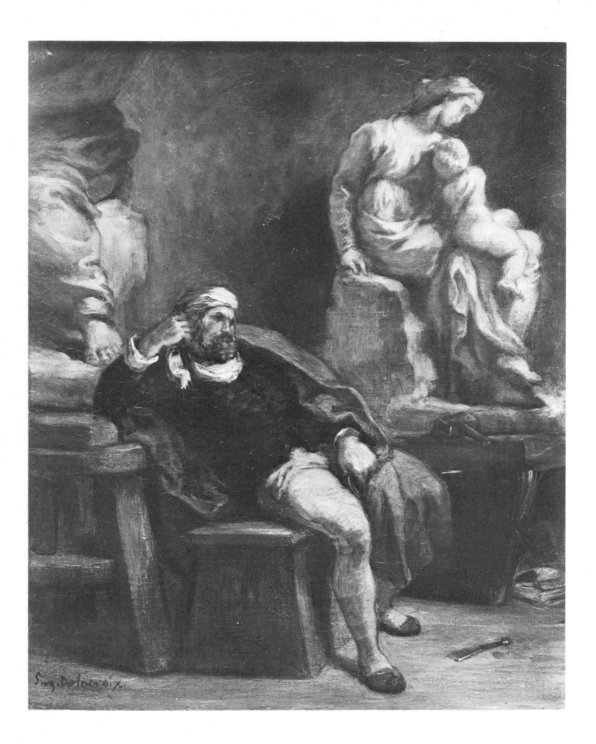

42. *Michelangelo in His Studio*, 1850. Delacroix

works, stopped working. Boredom seized him: perhaps he exaggerates this boredom and disgust, for in his discouragement he feels inferior to his rivals and asks himself "What is the importance of glory! What is the importance of the future!" ' Delacroix had already consummately illustrated this mood in his image of Sardanapalus, a great man who, finding himself unable to affect events productively, hardly looks at the destruction of the best and most beautiful things in his world. The 'indifference' of Sardanapalus to the real world may have as much of the artist as of the cool dandy about it, and perhaps Delacroix intended the monarch to be exalted as a prophet like the artist in de Vigny's *Stello* (1832). In a passage sounding like a biblical paraphrase de Vigny wrote: 'your kingdom is not of this world on which your eyes are opened, but of that which will be when your eyes are closed.'

An historian of the epoch has divided Romanticism into two periods: 'individual romanticism, up to 1829, and social romanticism after this date.'[44] A good indication of this change can be seen in Sainte-Beuve's essay on 'The Hopes and Desires of the Literary and Poetic Movement after the Revolution of 1830',[45] which asserts that art after 1830 turned popular and began to reflect contemporary social movements. One senses a relaxation of the *mal du siècle* tensions of the Restoration during the Monarchy of July, and a deflection of energy from the earlier self-centered to more political and extroverted attitudes. The attractions of the egoist Byron waned sharply in the 1830s; although his works were still read, his audacious behaviour was no longer much emulated. Romantics moved in several directions all strongly related to their social values. Some turned back to a conservative Christian position – men like Louis Veuillot, who had in the early 1830s been attracted to Byron and Scott, and who by the mid 1830s was writing a refutation of Hugo's preface to *Cromwell*. Already in 1831 Lamartine, whose *Ode sur les Révolutions* alludes to a flawed monarch who can be no other than Byron's Sardanapalus, addressed Christians and Royalists frightened by the Revolution of 1830:

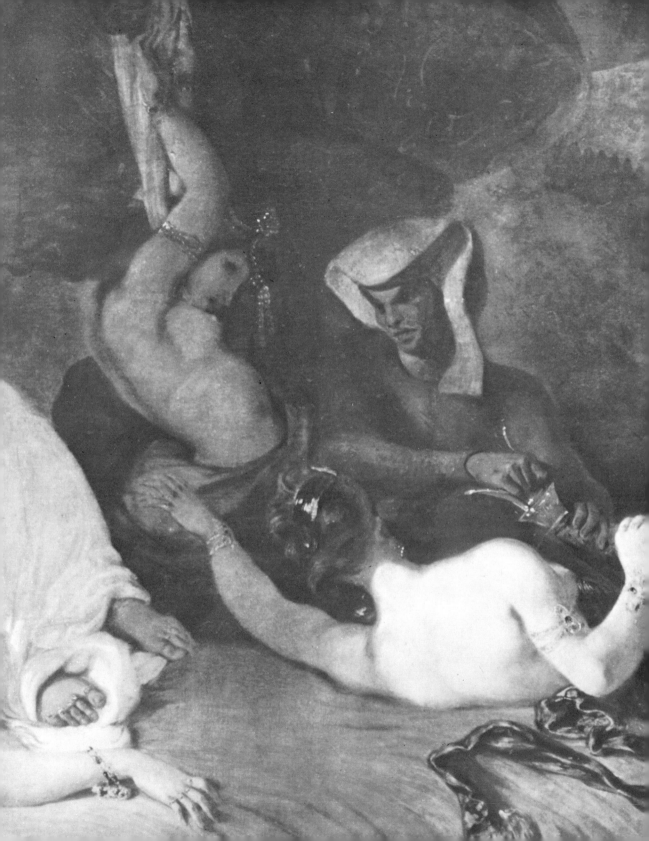

Nous donc, si le sol tremble au vieux toit de nos pères
Ensevelissons nous sous des cendres si chères,
Tombons enveloppés de ces sacrés linceuls!
Mais ne ressemblons pas à ces rois d'Assyrie
Qui traînent au tombeau femmes, enfants, patrie,
Et ne savaient pas mourir seuls;
Qui jetaient au bûcher, avant que d'y descendre,
Famille, amis, coursiers, trésors réduits en cendre,
Espoir ou souvenir de leurs jours plus heureux,
Et, livrant leur empire et leurs dieux à la flamme,
Auraient voulu qu'aussi l'univers n'eut qu'une âme,
Pour que tout mourût avec eux!

Others became politically active, anticipating realistic and socialistic trends of the 1840s and 1850s. But some of the best artists retreated to their own private art, ignoring the social currents of their time. The art of Delacroix (whose personal crisis in the late 1820s and early 1830s occurred by chance at about the same time as the political revolution) gradually eased away from the melodramatic intensity of which his *Sardanapalus* is the most characteristic example.

Whatever the impact of Byron on the artist, and the parallels between their versions of the theme of Sardanapalus, it has recently become clear that the play did not alone inspire the painting, since the play does not include the slaughter scene which serves as a prelude to the suicide by burning, nor the 'Bactrian woman Aischeh' who hangs herself in the background [43] – both details found nowhere before Delacroix's treatment of the scene. In contrast to all other versions we know – dramatic or pictorial – Delacroix nowhere mentions or represents in sketches the major character Myrrha, Sardanapalus' concubine, who is replaced in the painting by Baleah, a man.[46] The text accompanying the catalogue entry for the painting in the Salon of 1827–8 was written by Delacroix and thus illuminates his ideas, in its explanation of the complicated actions depicted: 'The rebels besiege him in his palace ... Reclined

43. Detail of *The Death of Sardanapalus*

on a superb bed, above an immense funeral pyre, Sardanapalus orders his eunuchs and palace officers to slaughter his wives, his pages, even his favorite horses and dogs; none of these objects which had served his pleasure was to survive him . . . Aischeh, a Bactrian woman, did not wish to suffer a slave to kill her, and hung herself from the columns supporting the vault . . . Baleah, cup-bearer of Sardanapalus, at last set fire to the funeral pyre and threw himself upon it.' Although Delacroix depicted the moment just before Baleah brings a torch, and eliminates the dogs, he does include the massacre, and in general the text and the painting correspond well, but only as a prose paraphrase corresponds to a poem: none of the mood or real impact of the painting is suggested.

Noting that Delacroix's caption for the Salon catalogue is set in quotation marks and has ellipses, Beatrice Farwell[47] tried to show that although the massacre could not be traced to Byron's play, it was not invented by Delacroix, but derived from an unnamed source. But what source? Nowhere in his own or his friends' writings is a plausible source so much as mentioned, nor is there any record of a play about Sardanapalus that Delacroix might have seen in London during his visit there in 1825. Miss Farwell sought in a number of far-fetched places for what can only be called unconvincing models for the massacre – a presumed second-rate theatrical spectacle (all the less likely since none of the contemporary critics refers to any play other than Byron's). Failing to find such a source, she reluctantly acceded to the opinion held by earlier writers that Delacroix may have invented the massacre, although she still suggests the possibility that a text such as Firdausi's *Shah-Nama* might have inspired the idea.[48] But in seeking a plausible source for the massacre in an Oriental text, Miss Farwell and others have overlooked a very accessible Western candidate, the original source for Byron's play, Diodorus Siculus' book (as presented in Mitford's *History of Greece*, to which allusion was made in all the early editions of Byron's play), which was most probably known to Delacroix. This book, which served as a source for many eighteenth-

century paintings, contains a passage which might have suggested the massacre scene to Delacroix. In relating the history of Alexander the Great, Diodorus tells of his contest with a predatory clan from Marmara, a town on the eastern border of Lycia. Being on the verge of defeat, the young men made the atrocious compact to kill all the women, children and old men. 'A general feast preceded this purposed impious sacrifice . . . when all had taken their fill, the signal for what was to follow was given by setting fire to all the houses.' There occurs in the very next chapter as given in Mitford's book the story of Alexander's discovery of Sardanapalus' monument at Anchialus bearing the notorious inscription: 'Eat, drink, play: all other human joys are not worth a fillip.'

Whether or not some more or less remote piece of prose or poetry contained elements of the story used by Delacroix we need not speculate, since the most important fact about the iconography is the uniqueness of its presentation. Thus, no less extraordinary than the massacre is perhaps the bed in Delacroix's painting, since in all earlier examples the king has himself immolated on his *throne* – as in the conclusion to Byron's play. In this departure Delacroix actually proves to be close to one side of Sardanapalus' legend and personality; for, as we have already noted, the bed and the pillow had long been associated with Sardanapalus. Thus, the huge bed becomes at once a perfect attribute of the main character, and a foil, bitterly ironic, for the terrible death of the hero amid resplendent sensual luxuries all of which are about to be destroyed by burning.

Following a line of inquiry similar to Miss Farwell's, Lee Johnson, basing himself on a sketch for the painting which refers to 'Etruscans', tried to discover a source for the massacre in pseudo-Etruscan art possibly known to Delacroix; but he has unfortunately exaggerated – at the expense of the illustrated volumes of Sir William Hamilton's collection of antiquities [49] – the analogies between some forms in the painting and certain engravings after 'Etruscan' vases and sarcophagi.[50] Lee Johnson is surely correct in calling attention to the reclining figures on genuine Etruscan

sarcophagi as a model for Sardanapalus' pose; but he does not develop the parallels between Sardanapalus and the Etruscan (or Greco-Roman) figures far enough. What must have struck Delacroix about such figures is that they are depicted equally as reclining on an *accubitum* or sofa [44] used for banquets by the Etruscans and Romans,[51] and as effigies of the dead on sarcophagi [45]. The poignant union of festivity and death would not have been lost on the restless imagination of the young artist.

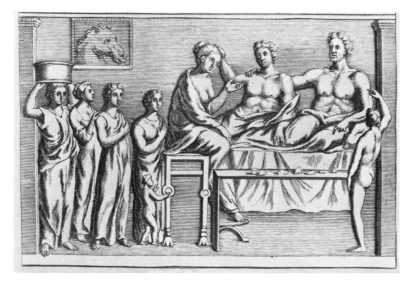

44. *Banquet Scene*

Like other Romantics, Delacroix used materials common to his own period and familiar to his public; but, as has been well observed: 'His contribution lay in the markedly personal character of his interpretation of the iconography common to the Romantic movement in England as well as in France.'[52] Clearly this personal expression is tied to Delacroix's own emotional life, in some respects inseparable from the inner workings of his creative mind. I regard this link as especially important for the *Sardanapalus*, perhaps his most intensely personal expression, despite its obviously external source. Delacroix himself indicated what he considered to be the nature of grand art in an undated entry in his *Journal*: 'The dis-

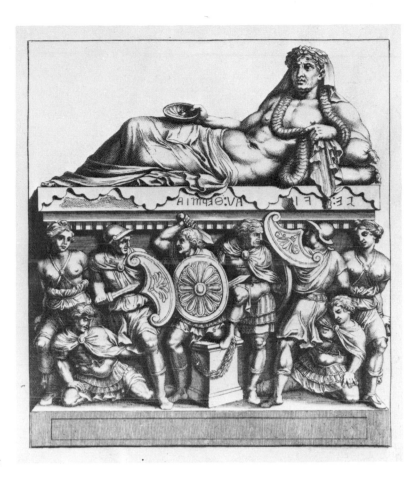

45. *Sarcophagus*

tinctive character of rare men is to have a stamp which they impress
on all their works in such a way that beauty is always colored by
their [personality].'[53]

Delacroix's originality often emerges clearly in the freedom with
which he treated his sources. In his *Marino Faliero*, for instance, he
causes the bloody head of the doge to be thrust directly out at us,
thereby illustrating an event which for the sake of decorum occurs
off-stage in Byron's play, which was his literary source. And in the
Sardanapalus, as we have seen, he added the massacre of beautiful
nudes. The changes he introduced into his visual sources in order
to perfect his composition or intensify his expression become clear

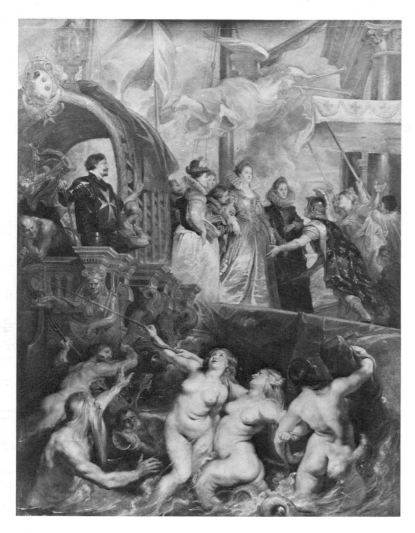

46. *Disembarkation of Marie de Medici at Marseilles*, 1625. P. P. Rubens

through study of his sketches for the *Sardanapalus*. Thus, the nude being stabbed in the foreground has been convincingly derived from the blonde nereid of Rubens's *Disembarkation of Marie de Medici at Marseilles* [46], part of the famous series of paintings, then in the Luxembourg Palace, and now in the Louvre.[54] Delacroix's figure reveals a powerful adaptation of the Rubensian beauty to the new plastic and emotional context. Even more strikingly, the melancholy nude propped against the bed between the stabbed

woman and the elephant has been traced to a caryatid in the same painting of Rubens.[55] The elephant, too, was added to the originally simple square bed as a dynamic element (suggested – as we can see

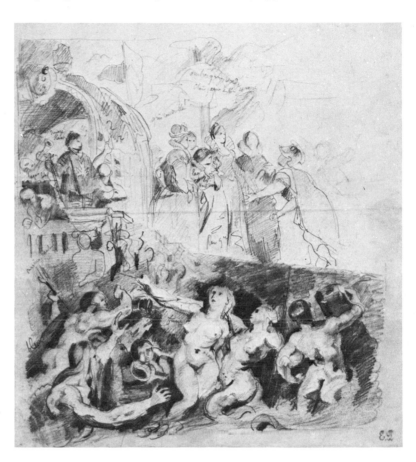

47. Drawing after the *Disembarkation of Marie de Medici at Marseilles* by Rubens, 1820s. Delacroix

in Delacroix's drawing after the work [47] – in part by the volutes beside the caryatid in Rubens's *Disembarkation*) giving the corner that torrential downward thrust which annoyed many critics.[56] But there were many other aspects of the painting which were to provoke an unfriendly reception.

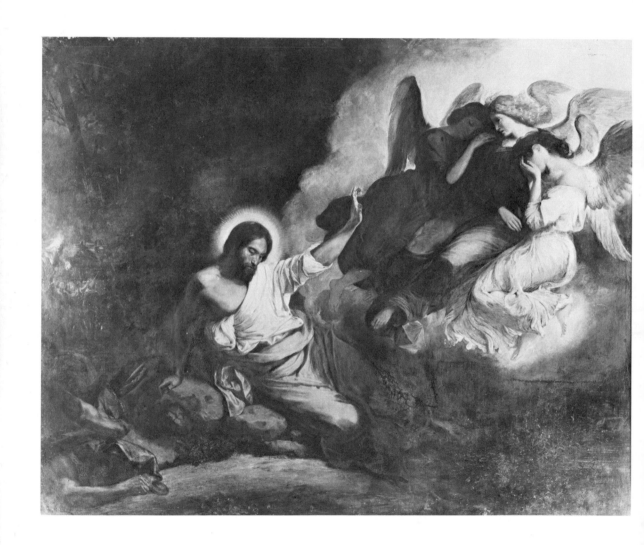

5. Reception

Delacroix submitted his *Sardanapalus* for the Salon of 1827–8 after his other exhibits – including *Christ in the Garden of Olives* [48] which enjoyed some success – were already on show. The *Sardanapalus* was accepted for the Salon on 14 January 1828 in one of the last *séances* of the jury whose members, Baron Gérard, Baron Gros, Ingres, Bosio, Cortot, Desnoyer, Percier, Turpin, de Crisse, Lenormand and de Cailleux, were largely unsympathetic but could hardly deny its right to be shown. Perhaps encouraged by the silver medal awarded him on 21 November for his contribution to an exhibition in Douai, Delacroix seems to have had sanguine expectations of public recognition. Although these hopes were frustrated they had a valid basis in the political and artistic situation. When the picture was put on show the famous battle between the *classiques* and *romantiques* was at its height, and the latter were clearly in the ascendant. Only two months earlier, on 5 December 1827, Victor Hugo had published his fascinating but unactable play *Cromwell*, with its famous preface which became the great manifesto of Romanticism in literature. The critical reception of Delacroix's painting can be best understood if it is seen against this wider background. For, at this moment, the party badges which writers and artists wore – or, more often, had thrust upon them – played a large part in determining attitudes to their work.

In this context the links between Byron and Delacroix and their respective renderings of the Sardanapalus theme acquire a more than merely iconographic importance. By the very selection of a Byronic subject, Delacroix willingly or unwillingly associated himself with a set of attitudes which would be instantly recognized by his public. But Byron's play serves as a reminder of the contradic-

48. *Christ in the Garden of Olives*, 1824–7. Delacroix

tions within the Romantic movement. Byron, like Goethe, was widely seen as a leader of the Romantics, but, again like Goethe, fiercely disclaimed any connection with them. (Delacroix likewise resisted being called a Romantic without reservation, and he was later to proclaim himself a '*pur classique*'.) And it is significant that in his *Sardanapalus* Byron meticulously observed the Aristotelean unities of time, place and action around which so much of the controversy between *classiques* and *romantiques* revolved.

To the modern reader this dispute over the Unities may seem trivial and tedious, if not absurd. But in it a very serious, deep-seated conflict in attitudes to the arts found expression. The opponents of the Unities were not simply contesting a passage in Aristotle, and not just drawing an important distinction between verisimilitude and truth, as had some writers already in the eighteenth century; they were also demanding the artist's liberty from the letter of arbitrary if long-established rules, not only in drama but in all the arts. Much of the controversy centered round the plays of Shakespeare who had, of course, been criticized in eighteenth-century France for his ignorance of or contempt for the sacrosanct Unities as well as errors of 'taste' (especially the free mixture of tragedy and comedy). Stendhal's Romantic manifesto *Racine et Shakespeare* (1822), which was later to be called the 'textbook of the Romantics' (and was quoted by Delacroix), appreciated both Racine and Shakespeare. Stendhal observed that even a 'classic' like Racine was at first challenged for his 'Romantic' novelty. In his discussion of modernity, Stendhal was really making claims for artistic freedom, derived to some extent from German writing by way of Mme de Staël (and it is worth remembering that Delacroix also was intimately familiar with her work). Victor Hugo's first Romantic manifesto, an essay on Walter Scott (1823), includes a passage of particular importance for our present purpose – a defense of the description in *Quentin Durward* of an orgy ending with a murder which he called both beautiful and necessary for the total effect. In the preface to *Cromwell*, however, he not only defended Shakespeare

but advocated a Shakespearean mixture of genres and, especially, use of the grotesque. 'Shakespeare, c'est le drame', he wrote; 'et le drame, qui fond sous un même souffle le grotesque et le sublime, le terrible et le bouffon, la tragédie et la comédie.' On the same page he remarked on the mixture of classical beauty and the grotesque in two great paintings of the Last Judgment by Michelangelo and Rubens (artists particularly admired by Delacroix).

Though primarily concerned with literature, and mainly dramatic poetry, the battle between *classiques* and *romantiques* influenced and sometimes determined attitudes to the visual arts. And though primarily aesthetic, it had political and social connotations. For the *romantiques* were at first associated in the public mind not only with English and German writers but with the allied powers who effected the Restoration and thus with the Bourbon government. Anglomania raged in Parisian society. It influenced taste in clothes, furnishing, and even attitudes to love. There can be little doubt that Byron and Scott owed some of their popularity in France to this vogue. English painters also enjoyed unprecedented popularity in France. And official support was given to them when, at the Salon of 1824, Charles X created Sir Thomas Lawrence a knight of the Legion of Honor and awarded medals to Bonington, Fielding and Constable. But Romantic attitudes underwent a change in the later 1820s. Disillusioned young men like Alfred de Vigny, who had expected royalty and lofty ideals to be compatible, began to turn against the mediocre leadership offered by the Restoration and to glorify an aristocracy of art beyond politics. On the other hand Hugo and other poets campaigned for political as well as artistic liberation. It was soon to be said that Romanticism was liberalism in the arts.

When Delécluze, an Anglophobe, Bonapartist, and former student of J.-L. David, dubbed Delacroix a '*Shakespearien*', he was therefore ascribing a whole set of attitudes to him – and scoring a number of points against him. He had first used this term in his Salon review of 1824 when he classified the opposing groups of

artists as Homeric and Shakespearean. Writing of the Salon of
1827–8 he dryly remarked that Delacroix was the only significant
supporter of the Shakespearean party since 'he is the only one who
persists in his bizarre ideas'. Delacroix had, of course, been affected
by the wave of Anglomania. He had been friendly with and learned
from the example of English artists, in Paris and on his trip to
England. Similarly he had, consciously or unconsciously, sided with
the opponents of the Unities, opting for truth even at the expense of
verisimilitude and seeking guidance not from the letter of artistic
rules but from the spirit of earlier works of art which he so deeply
loved and understood. Though Delécluze may well have been
aware of this, he probably did not know of Delacroix's genuine
admiration for Shakespeare. When an English company began a
Shakespearean season in Paris in the autumn of 1827, Delacroix
allowed his enthusiasm to bubble over in letters to several friends.
'A general invasion: Hamlet raises his hideous head. Fear the classic
daggers, or rather immolate yourself courageously for the pleasure
of us other barbarians.' And it is significant that he wrote this letter
while he was working on the *Sardanapalus* – to Hugo who had just
completed his *Cromwell* (and had already read parts of it to select
groups of friends) and was about to begin the preface in which he
proclaimed the rise of the Shakespearean and the fall of the old
French academic manner with its canon of the Unities. Like the
Romantic painters, Hugo aimed at strong effects rather than clarity
of design and logical development of action; and he was attracted
like Delacroix and other artists to vivid scenes introducing an
element of the grotesque – the witches in *Macbeth* or the grave-
diggers in *Hamlet*.

The conflict between *romantique* and *classique* dramatists was
echoed in the schools of painting divided along similar lines.[57] The
lack of clarity of the spatial setting, the dispersion of forms and the
disjunctive mood of the *Sardanapalus* would seem to correspond
loosely to the aims of the anti–classical writers. But the critical recep-
tion accorded to Delacroix's painting serves as a reminder of the

danger of forcing the parallel between his art and the works of the Romantic writers. That it should have been rejected out of hand by the *classiques* was only to be expected – though the reasons they give are sometimes of considerable interest. But it was by no means acclaimed unreservedly by others. 'Romantic' critics of the Salon reserved their praise for Boulanger's *Mazeppa* and Eugène Devéria's *Birth of Henry IV* [49] (bought by the State for the high price of 7,000 francs).

49. *Birth of Henry IV*, 1827. Eugène Devéria

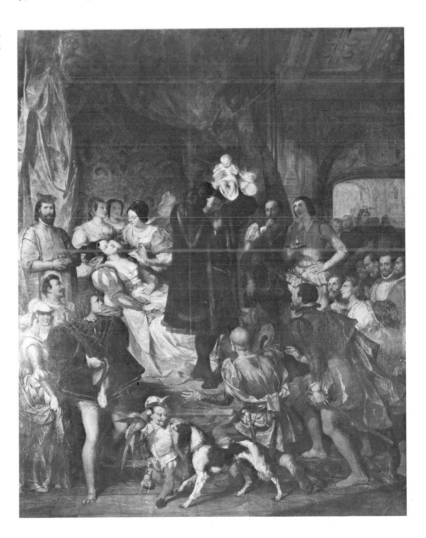

The unsympathetic critical response to Delacroix's painting is of interest as a measure of the distance between the high level of Delacroix's art and the taste of his contemporaries – especially the *classiques*, who exerted pressure on the artist to modify his subject matter and style. By one of those dialectical jokes of history, the stylistic heirs of David and the neoclassical revolutionaries of 1789, critics like Delécluze, had become the new reactionaries of the 1820s, opposing academic canons of linear clarity and emotional restraint to what they considered the clashing color combinations and excessive emotionalism being displayed in the paintings of the young Romantic school. While the neoclassic critics stood for a dryly chauvinistic but comprehensible academicism, their targets among the young French Romantics – like their counterparts in Germany and England – felt lonely, misunderstood and unappreciated.[58]

Critics of the *Sardanapalus* assaulted both its subject and form. 'Ch.', in the *Moniteur universel* of 29 January 1828, for whom 'the name [of Sardanapalus] has become synonymous with all that is most ridiculous and vile about debauchery and cowardice', faulted the artist for his handling of the character (based on Byron): it was hardly credible to this critic that 'an effeminate prince should magically become a tactician and a warrior capable of defending Nineveh'. But, with a touch of irony, Delacroix is praised for having 'chosen an error rich in images, instead of the unattractive and unpoetic truth'. 'Ch.' compared Delacroix's execution technically to that of Rubens, 'with his warm and vibrant color'. But outweighing the quality of his color are his faults of 'careless drawing' and 'confusion in the planes of the foreground'. The same critic praised highly Eugène Devéria's *Birth of Henry IV*[59] which, while related to Venetian art, is, he wrote, superior to it in its 'expression et convenances'; on the other hand, he abuses the *Sardanapalus* for its lack of decorum. Hopefully, he concludes, the artist, who still has time, will 'put a salutary bridle upon his picturesque and poetic imagination'.

Louis Vitet (1802–73), an influential political journalist and critic interested in art, discussed the painting in the *Globe* on 28 March 1828, in an ironical tone he was often to adopt toward the artist, but he praised Delacroix for choosing so highly imaginative a subject and noted the value for a colorist of being able 'to group on one canvas nude young girls and ebony-black slaves . . . But it is not enough to dazzle the eyes, it is still necessary', he went on, 'that the intellect be able to understand that by which the eyes are amused. If you only see half a horse, women thrown pell-mell here and there . . .' Despite its Rubensian richness of color, Vitet continued, you would not call this confusion a painting but a 'Persian carpet' or even a 'kaleidoscope'. The composition, cut short at the sides, lacks order, and the spectator even feels threatened that '. . . the gigantic bed that takes up so much place' will slide down onto his head. In spite of his harsh criticism of the disharmony even in Delacroix's use of color, Vitet – like 'Ch.' – found real talent in the artist though he would, he thought, do much better were he to try 'to distinguish a painting from a sketch'.

Among the wholly hostile critics Delécluze, a former pupil of David, is probably the most interesting. In the *Journal des Débats* on 21 March 1828 he harshly noted that the *Sardanapalus* 'has found favor in the eyes of neither the public nor the artists'. With its isolated details, confusion of lines and colors, and violation of the basic rules of art, the painting amounts to 'an error of the painter', a decline in quality from the *Christ in the Garden of Olives*, a work generally better appreciated at the time than the *Sardanapalus*.[60] We must wait for 'another work by him, and judge him anew' if we wish to be fair.

On a less sour note the reactionary *Observateur des Beaux-Arts* published in the course of 1828 a number of anonymous lampoons of the painting: 'M. Delacroix has ordered two moving vans to carry off the furniture of the *Sardanapalus*, three hearses for the dead and two buses for the living.' Another writer, perhaps dimly recalling the procedures of Géricault in painting his *Raft of the 'Medusa'*,

joked that 'Messieurs D (elacroix), S (cheffer), C (hampmartin), leaders of the new school, have obtained no award, but to compensate them for this, they have been allowed to spend two hours a day in the morgue. Young talents have to be encouraged'. But Champmartin's *Massacre of the Janissaries*, although called a 'painted sketch', never produced as strong a distaste as Delacroix's painting, probably because it did not unite, as the *Sardanapalus* did, voluptuous Baroque intensities of form and color with a macabre and sadistic slaughter scene. It was probably this explosive combination which provoked the sermons and lectures to Delacroix on how to 'improve' which we have cited.

In the *Quotidienne* of 24 April 1828, a writer signing himself 'P', regretted the loss of 'the arts of drawing' of sixteenth-century Italy and hoped that the bad reception of the *Sardanapalus* would help 'check the progress of evil that his first painting *Dante and Virgil* might have caused. There is no pupil who in casting his eyes on this bizarre painting could not convince himself that to produce a faithful copy of things it is necessary to know something besides how to throw bright colors on a canvas, and that there is some difference between a large well-lighted image and a painting well painted and above all well drawn.' An anonymous writer for the *Gazette de France* on 22 March 1828 sarcastically proclaimed that 'everyone agrees to recognize the *Sardanapalus* of M. de Lacroix [sic] as the worst painting [in the Salon]'.

Auguste Jal, in his volume *Esquisses, croquis, pochades . . . sur le Salon de 1827* (Paris, 1828), compared favorably Delacroix's Aischeh to the figure of Psyche by M. Froste which 'speaks less to my imagination than the Bactrian Aischeh hung from Sardanapalus' bed-head by M. Delacroix. Yet this victim is very ugly and Psyche is quite pretty! A linguistic barbarism in French has always displeased me less than a sentence without a thought.' Jal mixed praise and blame in other comments:

'M. Delacroix is not misled by system; he has painted his *Sardanapalus* with all his heart; he has given himself to it with passion,

with feeling, and unfortunately, in the delirium of his creation, he has been carried away beyond all limits. His very original talent is missing from this page traced under the inspiration of a great poetic thought. He wanted to compose disorder, and he forgot that disorder itself has a logic; he wanted to appall us with the spectacle of the barbaric pleasures on which the eyes of Sardanapalus sated themselves before closing forever. But it is impossible for a rational mind to extricate itself from the chaos amidst which his idea is confined. The destruction of so many living creatures on the funeral pyre of a most degraded tyrant was a magnificent horror, as M. Delacroix felt. His hand betrayed him . . . not only does the sum of its defects outweigh its beauties, but there are in fact no beauties. I wish to defend neither composition, style, drawing nor color. I might ask consideration for the pose of Sardanapalus, for the right arm of the young woman expiring on the bed of her master, for a horse's head of a first-class and brilliant tone, for some accessories . . . but no, let us ostracize all. Have a few good verses made us forgive Lamartine for his *Chant du sacre*? On the other hand, has the *Chant du sacre* prevented us from considering Lamartine a man of genius?'

M. Delacroix's faults are still preferable to those of more academic artists like Robert Lefèvre. Even Stendhal, who granted Delacroix the same energy he had found in Byron, noted also the same 'satanism' in the painting and in the play.[61] Victor Hugo was among the very few who applauded the 'magnificent thing' which he felt narrow-minded spectators could not appreciate;[62] he had only one regret – that Delacroix 'had not set fire to the pyre', for 'the beautiful scene would have been even more beautiful if it had as a base a basket of flames' (an idea, in fact, that Delacroix had considered and given up, as we have seen).

After the Salon of 1827–8 discussion of the painting diminished sharply, mainly as a result of the disappearance of the *Sardanapalus* from view (the painting was exhibited in 1861–2 at the Galerie Martinet, Paris; in 1878 at Durand-Ruel's in Paris; in 1887 at an exhibition of Puvis de Chavannes in Paris; in Copenhagen in 1888;[63]

for two days at the Haro sale in 1892, and after 1921 at the Louvre following its purchase). However, the sketch for the *Sardanapalus* (and the *reprise*) were occasionally exhibited after 1862, and helped sustain interest in the painting itself.[64] Lenormand could still freshly recall the painting in his Salon of 1831 (Paris, 1833) where he sighs with relief: '. . . we're far from the *Sardanapalus*, M. Delacroix has returned to a good road . . . ; a few more efforts and the cause of the new school [Romanticism] will be won by him who, despite several well-merited checks, is regarded by men of good taste as its most original representative.'

A few years later the painting received its first tribute of unqualified praise from Théophile Thoré writing in *Le Siècle* on 24 February 1837. He was probably relying primarily on his memory of the 1827–8 Salon, though he may, of course, have seen the picture in Delacroix's studio. Thoré wrote:

'The *Sardanapalus* is an immense composition in which the author has displayed all the resonances of his palette. *The Massacre of Chios* represented the many sides of passion pushed to its limits. The *Sardanapalus* represents the outward luxury of the Orient with its ceremony and sensual pleasure. *The Massacre of Chios* spoke above all to the heart, the *Sardanapalus* addresses itself more to the senses. It is painting for the eyes, succulent and streaming with color as fresh as flowers. So people invariably remark that Delacroix has imitated Rubens. The reproach of imitation has often been addressed to M. Delacroix because in fact several of his works seem to approach at times the Venetians, the Spanish or the Flemish. M. Delacroix is perhaps the most original and individual of contemporary painters. He is recognizable in the least corner of his paintings. Every stroke of his brush bears his signature . . .'

Thoré's minimizing of the subject and his point about painting as a perceptual phenomenon 'for the eyes' reverses the pejorative intention of this phrase as applied both by academic and narrowly religious critics, and points the way toward his own later criticism

and toward Realist and Impressionist approaches which were to dominate French art in the mid-century. Gustave Planche in 1853, using Thoré's terms but with an opposite judgment, observed that whereas the *Sardanapalus* addressed our minds with thoughts of suicide, the recent Apollo ceiling of 1851 spoke to our eyes.[65] The rarity of its exhibition probably accounts for the rather unspecific references made by sympathetic writers like Gautier and especially Baudelaire who in his *Salon de 1846* included the painting in the great series of the artist's works starting with *Dante* and *Chios*, without detailed criticism of it. (The poet was to praise the work again in general terms in the 1860s.) Signac, in his famous analysis *D'Eugène Delacroix au Néo-Impressionnisme* of 1899 cited some of the contemporary criticism of the *Sardanapalus* in order to ridicule its miscomprehension, but after a long passage about *The Massacre of Chios* he skips straight off to the 1832 trip to Morocco without once discussing the *Sardanapalus*!

The next real occasion for criticism of the painting occurred after 1921 when it was installed permanently in the Louvre. André Rigaud who favored the Romantics over their neoclassic contemporaries in *Comoedia* of 27 August 1921 reproduced a photo of the Salle des Etats at the Louvre showing the *Sardanapalus* beside Ingres's *Apotheosis of Homer*, a painting he felt would soon be justifiably put in storage somewhere. Thiébault-Sisson, writing articles in the *Journal des Débats* and the *Feuilleton du Temps*, both published on 31 August 1921, praised the painting which, he said, had been seen only once – in 1892 – since the exhibition in 1878 at Durand-Ruel's; and he cited Jal's criticism as an example of the incomprehension of nineteenth-century critics as regards this great work.

The subject of the painting has been all but ignored by twentieth-century critics, except as an inconvenient over-load carried by the work: Apollinaire, in his *Chroniques d'Art* of 1911, turned to the less Romantic aspects of Delacroix's art, and to some famous remarks made toward the end of his life that anticipated the luminosity that

Apollinaire appreciated, such as 'L'ennemi de toute peinture est le gris!' and 'Bannir toutes couleurs terreuses'.

J.-L. Vaudoyer, writing in the *Feuillets d'Art* of February/March 1922 found the work 'very romantic' and 'dated'. 'It evokes the epoch in which it was painted more than the subject it represents. It belongs in its manner . . . to the time of Gautier's *Fortunio*, Berlioz's *Retour à la vie*, of certain "satanic" pieces of Baudelaire. Beside that, the work is confused and bombastic. Finally, it is cluttered with "bric-à-brac" . . . These heaps of plates and dishes give me less an impression of richness than of tinsel; and the Egyptian night-table we see at the head of Sardanapalus' bed is as naïve, in its archeology, as the wretched hookahs that M. Ingres set beside his odalisques.' Yet Vaudoyer – like his nineteenth-century counterparts – found some details praiseworthy: he rhapsodizes about the flesh of the slave on the bed, comparing it to Rubens and Renoir; and he finds that 'by his pathetic and proud majesty [Sardanapalus] recalls Vigny's Moses and Hugo's Satan.'

Since Fauvism and Cubism the old subjects for painting have either totally disappeared or have reappeared in curious disguises. Thus, even the dream-illustrators among the Surrealists preferred the decadent and obscure academicism of the late Romantic Moreau to Delacroix's seemingly uncomplicated representations of traditional themes. While Delacroix's subject has fallen into oblivion among most modern artists, the 'disordered' composition that troubled earlier spectators has become a source of enthusiastic interest, at least to the famous Abstract-Expressionist, Barnett Newman, who said of it: 'In terms of scheme, it is interesting. The cut-out forms, the jumble. *Guernica*, even Rauschenberg, is related to this. It is what in journalism we used to call circus lay-out: make a mix-up of the page. It's like a 3-ring circus. A lot of things going on at the same time. And yet there's more to it than just a lot of ingredients. The eggs, the salt, the butter are all needed, but the omelet is something else . . . What is interesting to me here is the

spiral perspective, as against processional or vertical perspective. It is the first successful one I have seen. The picture really swings.'[66]

As for Delacroix himself, even before the published attacks of the critics, he felt an anxiety about exposing this ambitious work to the public, as evidenced by a letter of 6 February 1828 to his old friend Soulier:

'I have in effect finished my *Massacre no. 2* [a reference to Gros's remarks calling *The Massacre of Chios* "the massacre of painting"]. I've had to submit to quite numerous trials by the asinine members of the jury. I could speak long to you on this subject.

'I am continuing my letter after a two-day interruption. This morning they reopened the salon. My daub (*croûte*) is placed as well as possible. So that, success or failure will be my responsibility alone. When I came up to it, it made an abominable impression on me, and I hope that the excellent public won't have my eyes with which to judge my masterpiece. It's regrettable that I happen to write to you on a day when I'm so vexed.

'What an execrable profession it is to constitute one's happiness from the products of pure self-love (*dans des choses de pur amour-propre*)! There you have six months of work which wind up making me pass the rottenest day. Oh well, I'm used to things like that, so don't get alarmed for love of me . . . probably it's like all the other times when the first sight of my damned painting hung beside others' quite tortured me. It affects me like a first performance at which everyone whistles.'

After having been chastised by an unfriendly press, Delacroix despondently wrote again to Soulier, in a revealing and important letter on 26 April 1828:

'. . . The few parties to which I go out of habit, in order to be bored or amused, end on the whole by excessively tiring me physically . . . That doesn't get me any women. I'm too pale and too thin. The great occupation of my life is . . . to pay my rent every three months

and to live on a very modest scale. I am tempted to apply to myself the parable of Jesus Christ, who says that his kingdom is not of this world. I have a rare genius that does not let me live peacefully like a clerk . . . The love of glory [is a] deceptive passion . . . that always leads right to the abyss of sadness and of vanity! I do not speak of love, which in spite of the bitterest pain, has some moments that are really refreshing . . .

'Jobs and encouragement I must expect from no one. Those most favorable to me agree to consider me an interesting madman, whose deviations and odd behavior it would be dangerous to encourage. I have very recently had a little discussion with Sosthènes [Director of Fine Arts, criticized alike by Gautier and Delacroix]. The substance of it was that as long as I do not change my course I can expect nothing from that side [the state]. Heaven helped me keep calm during this conversation, in which this imbecile, who has neither common sense nor any sort of self-possession, was not at all calm. Today is the very day on which, at two o'clock, the distribution of favors and honors will take place at the Museum. I'll stop writing now and tell you about it [later].

'. . . Yesterday I went to this session. As I expected, the painting was not bought, and there were no commissions for the future . . . They mentioned neither my name nor anything I did . . . This shows that I'll have to turn to other ways.'

In fact, the imagery Delacroix invented subsequently never quite matched the disturbing power of this suicide-massacre, and his later work troubled his contemporaries more for its innovations in the rendering of form and color than for its intensely personal or erotic content.[67] This abatement of Romantic intensity was welcomed by the critics, as we have seen, and by 1839 the critic Alexandre Barbier could sigh with relief at 'the movement of reaction which has manifested itself, to the advantage of good sense and good taste. The orgy [an allusion probably to the *Sardanapalus*] has disappeared from the Salon.'

6. The Psychological Background

The sources of the peculiar power of the *Sardanapalus* – that brash and glorious statement of the *mal du siècle* – can be traced to obscure areas in the artist's personality. The uneasiness which the work engendered continues to haunt modern spectators. Here is a public Salon painting suggesting the bedroom intimacy of a sensuous eighteenth-century boudoir decoration, and an orgy become a *danse macabre* as love-making turns into slaughter. The frightening impact of the death scene on a bed was rarely emulated even by the Romantics (except in such popular art forms as the *tableau vivant* or wax works, and an occasional painting of Othello and Desdemona). But an engraving by Delacroix's friend Achille Devéria of *c.* 1829 for the French edition of Scott's *The Antiquary* [50] represents a

50. Sketch for illustration to Scott's *The Antiquary*, *c.* 1829. Achille Devéria

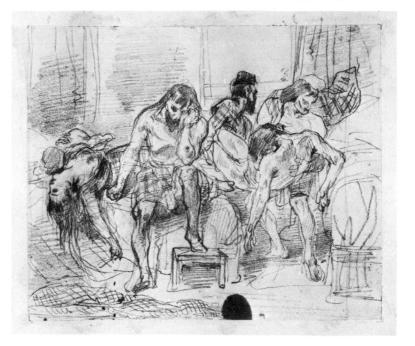

figure on a bed brooding like Sardanapalus and surrounded by dead bodies. (Devéria had engraved in 1825 Delacroix's *Tasso in the Madhouse* with its similarly seated and brooding hero, and like Delacroix and other Romantics he was attracted to ancient representations of naked corpses: he made a drawing, preserved at the Cabinet des Estampes, Bibliothèque Nationale, after a *conclamatio*, a Roman bas-relief of a funeral ceremony.)

We can follow the steps in nineteenth-century art leading from the bedroom symbolism of the *Sardanapalus* which projects features of Delacroix's sadistic fantasy under the guise of exoticism, to paintings which represent the artist's or his model's own *atelier*, bedroom or toilet. The factual and earthy imagination displayed in Courbet's *L'Atelier* (1855) soon evolves into the cooled-down realism of Manet's *Olympia* and Degas's bathers, both of which annulled Romantic melodrama (Olympia's bedroom – her professional 'workshop' – being the counterpart to Manet's *atelier*). Henceforth – excepting the unique Douanier Rousseau – a naïve Romanticism was to become impossible for major artists. As we have seen there is more than a grain of irony in Cézanne's *A Modern Olympia*, which renews the powerful Romanticism of Delacroix's *Sardanapalus* by reinterpreting the tempting nude figure as a private fantasy of the balding artist contemplating her like a bourgeois in a bawdy-house.

Paradoxically the *Sardanapalus* may be considered by the analytic modern viewer as an example of naïve artificiality. In its elaborate stage-mechanisms it exposes more than the artist wished of his own attitudes to love and death. The themes of sex and death linked so explosively in this Salon painting recur throughout Delacroix's *Journal* and *Correspondance*. But the public expression of these intimately private fantasies would have been blindly rash had there been no wave of Romantic excess supporting the artist. A particular reassurance was provided by Delacroix's momentary collaboration with his friend Poterlet, a mediocre painter and en-

graver; for Poterlet probably helped him to realize the most striking and grotesque image of death in the painting, that of Aischeh, the 'Bactrian woman' who hangs herself in the background [43]. None of Delacroix's surviving sketches for the painting shows this figure, so we may presume that he had not yet conceived it before consulting Poterlet. We know that when Delacroix faced problems in the work which he felt unable to solve to his own satisfaction he asked Poterlet to make an oil sketch after his own, and then adopted some of his friend's ideas – as in the case of the *Christ in the Garden of Olives*, of which Poterlet also made a lithograph.[68] The contribution of Poterlet's sketch was perhaps similar to that already discussed of Byron's text: to provide a stimulus (though one much narrower than Byron's) from which the artist could take off and develop his own ideas.

Through its evident tensions the *Sardanapalus* more than any other of Delacroix's paintings reflects the presence within himself of opposed impulses, a trait of the artist characterized by Baudelaire in his concise and penetrating phrase: 'Delacroix was passionately in love with passion, and coldly determined to seek the means to express the passion in the most visible way.' This conflict of impulses can be found in the artist as far back as we can trace his thought, especially in his unpublished juvenile notebooks at the Institut d'Art et d'Archéologie in Paris dating from his school years between the ages of fourteen and sixteen. An ambivalence about eating runs through his scribblings. He expressed an urge to eat without limit in his obsessively repeated phrase '*largo satiare cibo*' ('I eat abundantly to sate myself'). Some years later in a letter to his friend Félix Guillemardet of 20 October 1820, he confessed, 'I am unworthy that you should talk to me of philosophy. I am a slave of my senses'. But in fact, as reported by Baudelaire and others, Delacroix was well known to have eaten very sparingly (presumably throughout his life) and to have lived with an asceticism he justified by reasons of health. A similar set of opposed impulses or ideas is

apparent in his attitudes to women: his most impressive images of women have to do not with tenderness and maternal warmth but rather with their being objects of sadistic torment and death or themselves the murderers of their own children (*Medea*).

Delacroix's low opinion of women was summed up in a sentence he addressed to Baudelaire, who reports it: 'How on earth could a woman be melancholy?' – melancholy being a noble sentiment unattainable by such creatures. But another attitude to women was associated with his feelings toward his mother, who seems to have occupied a special place for him. His intimate ties to his mother are hinted at in a sentence in his notebooks written in almost illegibly small letters in the year of his mother's death (she died on 3 September 1814): 'Si la mort doit t'enlever à mes tendresses, je renonce à tout . . . tout est perdu pour moi' ('if death is to take you from my endearments I renounce everything . . . all is lost for me'). This attachment to his mother persisted into later years, and he dedicated his *Journal* to her memory, with the pious hope that he would never write anything that would cause her to blush. Other entries in the journal reveal that at times his attitude toward women was peculiarly modest and shy. On 13 September 1822, for instance, he wrote: 'I respect women: I could not say to women things which are entirely obscene. Whatever idea I may have of their feebleness, I myself blush, when I wound that modesty whose exterior at least ought not to desert them.' In spite of such assertions we find contradictions of these prudish sentiments in his sensual art and more emphatically in his numerous risqué sketches that caricature especially male authority: *Lord Ure* [51] is shown at his stools (*l'ordure*), and *L'Abbé Stialité* [52] engaged in sexual congress with a goat (*la bestialité*).[69]

In the same spirit as his allusions to his mother are such entries as that of 6 June 1824 in the *Journal*, in which he cites (in English) – like a good boy – Benjamin Franklin's motto for the productive middle-class: 'Early to bed and early to rise, etc.' Here we touch on another mental conflict – his conflicting attitudes toward artistic

51. *Lord Ure*,
c. 1817. Delacroix

52 (*above right*). *L'Abbé Stialité*,
c. 1817. Delacroix

creativity. Like others of his generation, a sufferer from the *mal du siècle*, Delacroix did not in his youth feel unequivocally committed to productivity. Manifesting an ambivalence characteristic of the bourgeois Romantic he aspired to leisure as an aristocratic luxury displayed, for example, by his Sardanapalus, and at the same time abhorred it as a sign of failure and unproductiveness beneath his lofty genius. On other pages of his schoolbooks, he wrote a mocking allusion to himself as 'a good boy': 'Oh le bon garçon que c'est Eugène; Il signor della croce il buon ragazzo che non a fatto male a nessuno da vero.' This play in Italian on the Greek roots of 'Eugène' ('*eu*' meaning '*bon*'; 'gene' meaning '*garçon*') and on the obvious Christian meaning of 'Delacroix' is carried much further in his transformation of Eugène (coupled with the name of the Greek hero Achilles) ambivalently into both 'chien' and 'génie', by picking

syllables from each name and variously recombining them (A *chi* lle, Eug *en*; Eu *gen*).[70]

This self mockery – rather like his caricatures of the Abbé and the Lord – perhaps also implies a doubt about his ability to become a husband and father. In later years Delacroix's marital interest (a rather desultory one) was overshadowed by his need for an ideal 'mother' to support his genius. This yearning is betrayed in the most revealing way perhaps in his essay on Gros, in words which might be applied to himself:[71] 'He [Gros] wished to live close to his mother. "If my mother were close to me," he writes, "she would regulate my existence [Delacroix's underlining] . . ." Regulate your existence, poor artist! Yes, without doubt, that is the secret unknown to men dominated by the imagination . . .' (In this connection we may remark that whereas Delacroix himself never married, he significantly kept his house-keeper Jenny le Guillou as his *gouvernante*, who maintained a strict *régime* for her master in his later years.)

In his evidently irrepressible imagination the 'good boy' turned often to the demonic, to themes of 'evil genius', like Faust's Mephisto, and produced fantasies containing sadistic and sensual images of chained nude figures on the same pages of the juvenile notebooks where he calls himself the 'good boy'. In a notebook of some years later[72] we find a highly revealing series of drawings, in which religious passion and sexuality succeed one another: a deposition [53] with emphatic nails in the foreground; then a Pietà [54] in which mourning women surround the body of Christ laid out on a bed; and on the back of the Pietà [55] four couples reclining in various positions of sexual intercourse: the death-bed is the obverse of the love-bed! Denying the guilt over his sensual impulses seems to have driven Delacroix to greater excesses in the Romantic orgies he attended, as we shall see.

Delacroix's oppressive 'faithfulness' to his mother prevented his ever 'betraying' her by marrying a Frenchwoman, and accounts for the apparently paradoxical discovery of his ideal woman to be

53. *Deposition*,
1820s. Delacroix

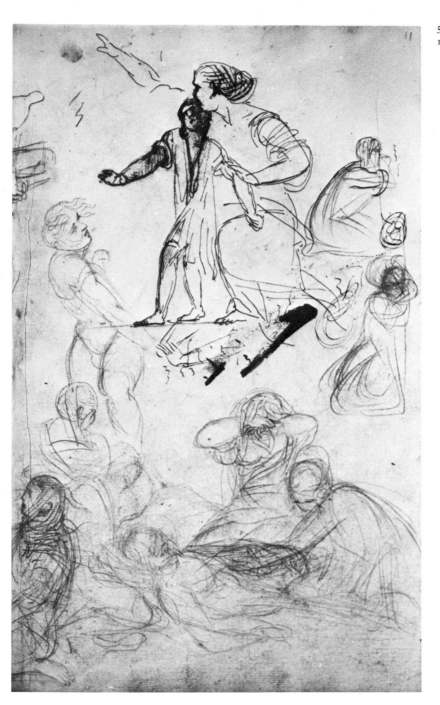

54. *Pietà*,
1820s. Delacroix

a mother with her children, spinning her yarn in the midst of an Algerian harem.[73] He probably both required and resented this self-deprivation, to judge from his fascination with the theme of persecuted genius, which he sometimes presents in association with frustrated sensuality, as in the following example. At the very beginning of his *Journal* (3 September 1822), just after a long monologue on a sexual adventure of the evening before, he turns his attention to his project to paint *Tasso in Prison*, which concerns essentially the persecution of the great poet by the vulgar crowd. A similar sequence of thoughts appears in the next entry (5 September 1822), where he recounts first a frustrated escapade with a servant, then an anecdote about a ship's captain who was nailed to a plank and thrown into the sea, and next a 'factual' description of how the Turks slaughter the wounded as well as prisoners on the field of battle. All this is followed by his first delicate allusion to his recently deceased mother, already quoted above. What strikes the reader of these passages is the manner in which Delacroix associates the erotic with violence, while divorcing it from any tender feelings. During the 1820s Delacroix appears to have had sexual intercourse mainly with his models, whom he kept emotionally as distant as prostitutes, often listing the precise amount of money given beside a record of the number of times they had copulated. Delacroix seems to have regarded his sexual behavior as a surrender of energy, and he was always chary of such loss, always involved in an economy of his gains and losses of energy.[74] We know of this sexual activity in the 1820s, since he often wrote next to some allusion to a model the Italian slang expression '*io ho fatto una chiavatura*', probably learned from conversation with an Italian helper, and meaning 'I've had sexual intercourse'.[75] *Chiavatura* is a substantive of the verb *chiavare*, literally 'to nail' but colloquially 'to fuck'. It seems to me that the double meaning of this word – probably known to Delacroix – provides one more link between the erotic and the painful. One thinks in this connection of his story of the unfortunate captain who was nailed to a plank, or of his paintings of Christ,

a figure whose Crucifixion held more personal than religious significance for him as a masochistic image charged with guilt for sin.

Given this background in the personality of Delacroix, there is little wonder that we find a constant link in his art between the erotic and death, as in the *Sardanapalus* in which the sexual delights promised by the beautiful nudes in seductive postures are transformed into mortal struggles or the surrender to death. Gautier beautifully describes them as '*fleurs de harem* . . . [who], surprised in the postures of death, which are precisely those of sensual delight, emit a violent odor of flesh'.[76] The sadistic imagery of his painting seems directly linked to his sexual behavior in the 1820s, to judge from several entries in his *Journal* made while working on the *Massacre of Chios*: in May 1823 he noted that he had had 'ravishing moments' with Sidonie, a model for one of the violated Greek women. On 5 March, 1824 he specifically speaks first of working 'on the head and torso of the girl attached to the horse', a beautiful nude Greek who is being dragged by a fierce Turkish horseman, and directly afterwards he writes 'Dolce chiavatura' (probably with his model 'Emilie R[obert]'). On 28 May, 1824 he wrote of a visit by his model Laure (whose languorous beauty reminds one of the nude beneath Sardanapalus, to judge from his *Woman with the Parrot* of 1827, for which she posed): '. . . she and la chiavatura, 5 fr. – *Ieri anche un altra con la nera* . . . Dufresne says that he is capable of devotion to all great undertakings [*grandes choses*], but that he sees their emptiness . . . I feel the opposite: I am devoted to great undertakings [*j'y rends hommage*], but I am too weak to accomplish them.' Sadistic fantasy seems to have been a recurrent stimulant to the artist's sexuality; and without it he may have felt disarmed, as though love and tenderness meant impotence (a reminder of his little-boy desire for his mother).

Delacroix's fear of sexual impotence[77] parallels his anxiety about his productivity as an artist, and he seems to have regarded both in terms of that conservation of sexual energy mentioned above. As a

young man his imagination doubtless overflowed with sexual fantasies, but when it came to performance – to expending his energy – he withdrew; thus, he noted with annoyance at himself how his resolution vanished in the presence of action and that 'when a girl falls my way I am almost annoyed, and would rather not have to act; there is my cancer.' No wonder that years later, in 1838, on what was obviously designed to be an amorous trip to Belgium with his old flame Mme Elisabeth Boulanger, he apparently fell short as a lover. As Escholier perceptively observes:[78] 'We know that the lovemaking abilities of Delacroix had their limits, and that these limits were quickly reached.' Hence, according to Escholier, Mme Boulanger's desertion of Delacroix in Belgium.

Delacroix's resistance to the loss of creative energy in sexual (or social) activity is epitomized in his resentment at the loss – as of the unstanchable flow of a vital fluid – of 'time' (a problem for many Romantics powerfully presented in Balzac's *Peau de Chagrin* of 1831). Naturally, as he grew older and more thrifty in the use of his physical resources Delacroix became increasingly anxious about this passage of time that eluded his control. Art, with its promise of immortality through posthumous fame, must have suggested to Delacroix a means to win the contest with his fear of death by rising beyond the temporary – a 'salvation' of sorts. Paradoxically, motivated by similar fears, he was constantly tempted by the opposite of creative immortality – mediocrity; in fact, he once exclaimed in his *Journal* 'I love mediocrity'.[79] In his early notebooks Delacroix repeatedly evidences his urge to be above the common crowd (as we have seen), to be superior and to conquer: phrases like *odi profanum vulgus* are set beside vainglorious ones like *superior sum, supero*, and *Delacroix . . . vainqueur*. But the hero, the conqueror, is essentially alone, a being with much to lose, and so an alternative to this solitary posture haunted the ambitious artist. By becoming 'mediocre' Delacroix would have the chance to resolve the anxieties about solitude attached to the problem of strong individuality. Love could certainly have mitigated his solitude, but, as he once

told Lassalle-Bordes, his assistant, he never felt 'strong enough to marry': he must have felt emotional union as a considerable threat. Temporary affairs with models or with married women could serve as partial substitutes for a mature love-relation, for he could pull back as soon as the threat of losing himself in the other occurred. In fact, sexuality remained always for Delacroix temporary, intense, and often bestial – the very image created by the great Romantic artist in his paintings.

The problems facing Delacroix in his attitude to sexuality and to life itself are clearly reflected in the conflicts and tensions of his painting where Sardanapalus – with whom he in part identified – observes with narcissistic self-involvement the destruction of life and youth a moment before his own death by poison. The mood associated with this scene is very close to the romantically despairing sense of transience which plagued Delacroix precisely in the midst of convivial company. Every year during his young manhood he met his friends on New Year's Eve to celebrate the festive Saint-Sylvestre with song, clowning and drunken carousal, as numerous amusing drawings attest. But sometimes the mood was shattered by the flash of awareness that the end of the year signifies growing old, and on one occasion he exclaimed of the Saint-Sylvestre: 'This day is the saddest of the year.' Delacroix's wild, even orgiastic behavior in some parties was notorious among his friends. Thus, Prosper Mérimée, in a letter to Stendhal, reporting a sexual orgy with six nude girls, described Delacroix's 'frenetic' efforts, his indescribable 'erotic enthusiasm', as he 'panted and gasped' and tried to take on all the girls at once.[80] Parties, then, helped him to forget time and death, and in the same sense the orgy offered a way to avoid the loss of self that a love-relationship might threaten. But the fear of death nevertheless obtruded, and Delacroix doubtless felt more than once like Sardanapalus, for whom the nude women and the luxurious objects around his bed signified both the desires of life and the imminence of death: a *vanitas* painting without a religious moral. During his troubled period of the 1820s a 'party' of nudes turned

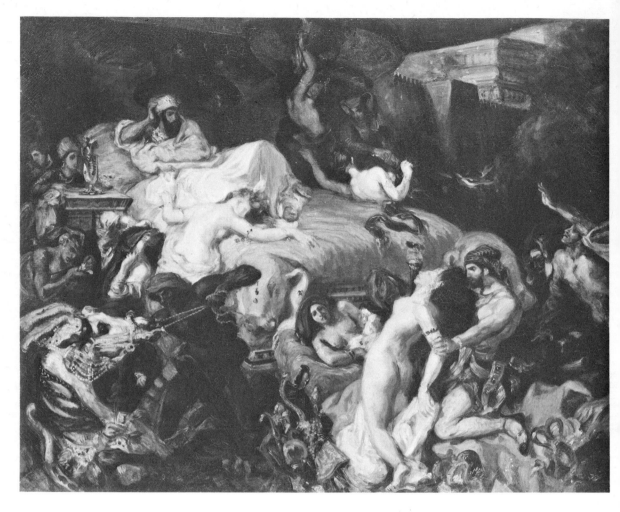

easily into a vision of blood and death, notably in *The Massacre of Chios* and the *Sardanapalus*.[81] Much of Delacroix's frenzied activity in sex and art at this time served him – it seems to me – as part of an unsuccessful effort to break out of the emotional bonds of his childhood. But the effort to escape through this explosion of sadism and sexuality from being his mother's 'good boy' apparently cost him too much emotionally. At first he merely dampened and denied the very pleasures he experienced, but he later withdrew to an externally more quiet life.[82]

56. *The Death of Sardanapalus*, 1844. Delacroix

Delacroix's intensity caused the tantalizing goal of living a tempered, calm existence to recede ever further from him even as he struggled toward it. We feel that in his famous *Dante and Virgil* it was the startled Dante or even the lost souls clawing at the boat rather than the philosophical Virgil with whom he could identify. And we find a resigned access to peace only in his images of sleep or death, as in his painting of the dead Christ of the Entombment or, especially, of the Christ on the Sea of Galilee (or 'Christ sleeping during the tempest' as he once called it) a theme that obsessed him. (He treated it about ten times in the 1850s.) The character of his Christ even in the highly praised *Christ in the Garden of Olives* was criticized for betraying either an excessively human suffering or a stoic resignation. He often called in vain upon his powers of creative imagination to bring him to the 'peace and plenty' that his *Orpheus* of the Palais Bourbon proffered to Greece: in the mural facing the *Orpheus* Attila destroys civilization, and in a despairing image dating back to the *Journal* of 16 May 1823, he pens a little scene about the death of genius in which 'the barbarian dances about the faggots'. Significantly, in his youthful projects for novels we find him musing over the idea of 'a painter of a great family . . . become a monk'. Immediately after this he goes on to write of the 'sentiment of the heart and of a sick imagination, the story of a man who, after having lived in society, finds himself enslaved by barbarians, or thrown on a desert island like Robinson Crusoe, forced to use his own strength and industry, which compels him to return to natural sentiments and calms his imagination.' Although it was in the imagination that Delacroix placed all his faith as an artist, he specifically says[83] that imagination has 'the power to destroy the fragile calm of philosophy', and calls imagination 'a fatal gift'.[84] But it was perhaps through his creative imagination that his destructive imagination was in part quelled.

In the face of his terrifying fantasies and sado-masochistic torments, he may well have found his best moments of peace through discharging in art that very imagination charged with unrealized

sexual energies. This 'sublimation' (in the psychoanalytic sense) led ultimately to a satisfaction totally within art, which allowed him to withdraw from the painful arena of real sexuality. Finally he was to call art (and not his models) his 'mistress', and to remark that 'the most beautiful works of art are those that express the pure fantasy of the artist'. Already in early works like the *Chios* Delacroix divided his attention between the emotionally charged drama and the more purely pictorial aspect of the landscape (which he is supposed to have retouched after seeing the work of Constable). The painterly excitement Delacroix felt for the texture and color of the landscape in *The Massacre of Chios* invested the best works of his maturity (like the *Jacob* of Saint-Sulpice) where the dramatic illustration became less and less obtrusive in comparison with form and color.

Before his riper years when he retreated or rose into total absorption in his art and when he arrived at an impressive self-understanding through the analyses of his *Journal*, Delacroix often thought of death as a release from his private hell – the surcease of life's efforts and pains. On the death of the physically tormented Géricault he expressed sympathy with the phrase 'your pains have ceased'. Earlier, while Géricault was on his death bed, he had commented on the artistic treasures surrounding him. Both sentiments point to those displayed a few years later in the *Sardanapalus*. One of Delacroix's sketches for the painting [13] even contains the words – significantly in Italian, like his expression for sexual intercourse '*chiavatura*' – '*io sono tranquile fra poco*' ('I shall be tranquil in a little while'). Delacroix shared his dream of tranquillity with other passionate Romantics like Lamartine. It seems to me that many Romantics sought tranquillity as a remedy for their '*mal*', their inability to hold together their emotional and intellectual lives. The older moral and religious solutions apparently offered little to these spirits torn between secular-egoistic impulses and a yearning for love and security. Understandably the seventeenth-century attitude of *recueillement*, the concentration of thought and feeling on the spiritual side of self to the exclusion of 'earthly' preoccupa-

tions, failed for tormented young artists. The *mot-clé* for the Romantics of *recueillement*, along with other residues of a religious attitude such as *méditation* and *contemplation* were often transformed into self-serving but transitory maneuvers, momentary retreats especially available to the imaginative artist capable of building his own private fantasy-world. It was in this context that de Vigny wrote in 1835:[85] 'l'imagination et le recueillement sont deux maladies dont personne n'a pitié.' And given the failure of many Romantics to hold together in the face of a dissolved moral core and an open-ended quest for self, we can also understand why Baudelaire, terminating Romanticism and pointing toward twentieth-century awareness, equated the hero with the person immovably centred upon himself.

A revealing novel written by Delacroix when he was seventeen years old already expresses this yearning for peace at any price. The book concludes with a happy reconciliation of the young hero with his 'good father', after having learned 'a salutary lesson' from his wild adventures, which he sums up by quoting from Seneca's *Thyestes*: 'So, when my days will have passed without my making the slightest noise in the world, I may be able to die old, though plebeian. Death hangs heavily on him only who, too well known to the world, dies unknown to himself.' But before Delacroix could begin in earnest the struggle to find himself and 'escape upwards' into his art, he passed through the crisis of the 1820s, of which the *Sardanapalus* remains our prime record. Significantly he found in the philosophy of the ancient Assyrian a momentary means of escape from the very criticism which the painting aroused. Adopting the attitude of Sardanapalus in the face of disaster seems to have consoled him. In a letter to his old friend Soulier on 11 March 1828, after complaining of the maltreatment of the painting at the hands of the critics, he wrote: '. . . let us push on and try to have, before dying, a bit of peace and independence in this sordid world. A little library, some good wines and some other good things. The rest, as my ancient friend Sardanapalus says, is not worth a straw.'

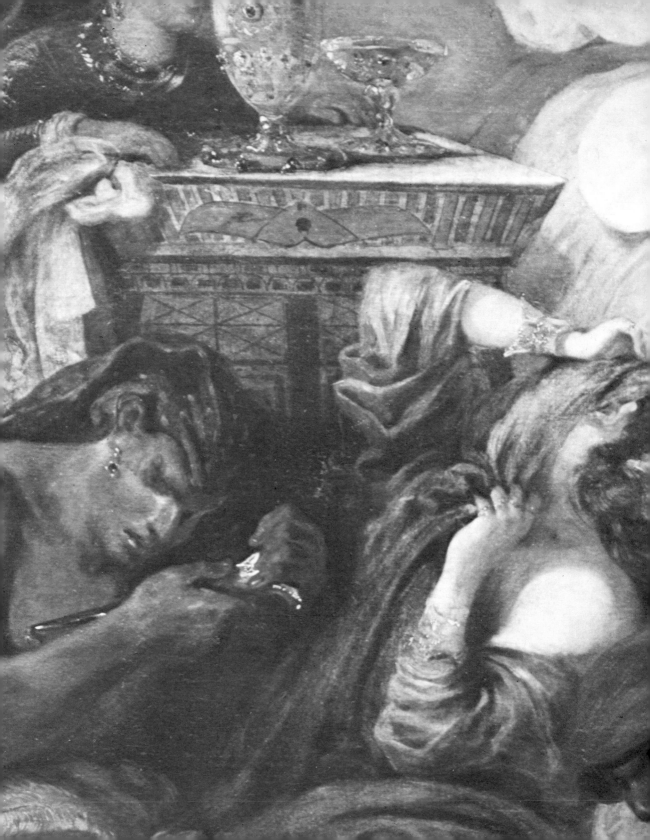

Conclusion

Delacroix's *Sardanapalus*, a richly complex masterpiece, demands and deserves the most careful examination. The great painting unites the public features of a big Salon *machine* to an intensely private expression and combines traditional iconography with personally charged imagery. It has been considered here not only as a masterpiece of form and color but in terms of the psychology of the Romantic artist and also in the larger perspective of its period. For Delacroix transformed the typically early Romantic theme of a poet or artist studying ruins like a connoisseur before *objets de vertu* or a humanist dreaming of a lost classical past, into a scene at once intimate and public. The contemplator is here directly and personally involved in the death menacing all the beings around him. The sensual and sadistic permeate the whole enormous conception – even the archeological details, which, far from being shown as dusty museum pieces, are stained with reds suggesting the imminence at once of the blood bath and conflagration.

Without minimizing the role of the artist's gift in arriving at solutions to plastic problems, I have tried to show how his personality, functioning within a given historical situation, arrived at results that his public found unacceptable, and that he himself would never again quite match. The psychology of Delacroix – his personal imagery superimposed on the borrowed theme of the death of an Assyrian monarch, and his intense manner of realizing his vision – helps us to understand the nature of his 'Romanticism' and its varied impact on the taste of his own period and later times. The widely held view (embodied in commonplaces about romantic love) that there is an erotic core to Romanticism finds its justification in this painting, in which the artist's deepest personal attitudes to love

57. Detail of *The Death of Sardanapalus*

and women find expression. But in place of the tepid sentimentalisms of more conventional Romantic paintings, the *Sardanapalus* presents us with an image of love whose emotional fulfillment is thwarted by the sadism engulfing the figures.

The spatial conflicts and 'confusions' of the painting remind one of the emotional problems implicit in Delacroix himself but also belong within the range of the post-Davidian spatial representations. Romantic artists, impatient with academic compositions arranging models in a simple box space, frequently allowed the main figures to float on clouds or in water. In their pursuit of melodrama and of the suggestive or exciting fragment, the Romantics often highlighted some forms and cast others into deep shadow at the expense of legible composition. From now on even the spatial indicators still retained by the Rococo are minimized by advanced artists, and the whole continuum of space becomes increasingly ambiguous. The later nineteenth century and especially the twentieth century were to continue to play with flat and ambiguous spatial settings, usually without the dark drama of chiaroscuro. The truncation of figures in the foreground of the *Sardanapalus* such as the horse, which offended the sensibility of Delacroix's contemporaries, should be seen as a Baroque expressive device fitting perfectly into the mood of cutting and butchery, and not at all in terms of the Impressionist use of framing to suggest the informality of the candid camera.

Impressionists like Renoir still found admirable parallels to their own art, even in Delacroix's most Romantic works, through concentrating on aspects of form and color while ignoring the content. Renoir compared Delacroix's battle scenes to bouquets! But Baudelaire – sensing the artist's ability to mask terror with art – in his famous essay on Delacroix more accurately characterized this side of his art as 'a volcanic crater artistically concealed behind bouquets of flowers'. While most modern artists, being primarily dedicated to the formal elements of painting, have paid little attention to the subject of the work, Delacroix's contemporaries were

strongly affected since they were still accustomed to seeing art as theater and empathizing with the actions and emotions of the figures represented. This imagery helps to account for the special abhorrence most of Delacroix's critics, including many Romantics, expressed for the painting. Later viewers have responded more openly to what may also have unconsciously troubled Delacroix's contemporaries, its 'impurity', its mixture of personal image and painterly sensitivity. Is it, perhaps, this very complexity, tense and combustible, that accounts for the painting's continuing capacity to challenge and evoke strong responses even among spectators unaware of Sardanapalus' story or of its possible bearings on Delacroix's own experiences?

Appendix 1:
Charles Rivet on Delacroix's *Death of Sardanapalus*
(Achille Piron, *Eugène Delacroix,*
sa vie et ses oeuvres, Paris, 1865, p. 70 ff.)

En lisant le drame assez peu lisible de lord Byron, il avait été frappé du côté pittoresque du dénoûment. Un despote farouche et blasé qui s'ensevelit sous les débris de son palais, sacrifiant avec insouciance à son orgueil les objets de son affection, les instruments de ses plaisirs et les trésors de son luxe oriental : c'était une scène qui s'était d'abord présentée à son imagination, empreinte de deuil et d'horreur. Il avait pris la palette sous cette impression; en quelques heures, une esquisse d'un caractère énergique et sombre avait apparu sous son pinceau.

Quand il en vint à l'exécution, et que, sur la toile, la plus grande qu'il eût abordée, il entreprit de peindre, d'après le modèle, cette esclave à moitié nue qui se jette sur le lit de son maître, implorant la pitié et demandant grâce pour sa jeunesse et sa beauté, il se laissa entraîner par les séductions de l'imitation. Il fait palpiter l'opale et l'or sur ce torse aux reflets éclatants, sur ces épaules, sur ces bras d'une couleur dont les aspects chatoyants l'enivrèrent d'enthousiasme. Il fit alors une des plus ravissantes études qui aient charmé les yeux; mais il perdit le ton général du tableau, pour conserver ce qu'il avait fait avec tant de verve et de bonheur. Il modifia donc peu à peu tous les accessoires, et la scène entière prit un effet tout différent de celui qu'elle devait d'abord exprimer.

Quelques années après, quand il revit l'esquisse et que je lui rappelai les émotions dont il avait subi l'influence :

– Savez-vous ce que cela prouve? me dit-il. C'est que je n'étais qu'un écolier; la couleur, c'est la phrase, c'est le style. On n'est un écrivain que lorsque l'on est maître, et qu'on la fait obéir à sa pensée.

Aujourd'hui, ajouta-t-il, ma palette n'est plus ce qu'elle était. Elle est moins brillante peut-être, mais elle ne s'égare plus. C'est un instrument qui ne joue que ce que je veux lui faire jouer.

Au surplus, ce fut sa dernière faiblesse paternelle. On a pu remarquer depuis, en rapprochant des oeuvres qu'elles ont préparées, les nombreuses esquisses qui ont été mises en vente, combien la pensée qui les a conçues a été scrupuleusement obéie dans l'exécution. . . .

M. Sosthènes de la Rochefoucauld, surintendant des beaux-arts, fit venir Delacroix et le pria de *changer de manière*. Delacroix se retira mal édifié, et dit, au retour, à ses amis que, depuis ce moment, son *Sardanapale* était grand à ses yeux, et lui semblait être une oeuvre capitale.

Il raconte ainsi que nous allons le voir cette entrevue au ministère.

'Les salons de peinture n'étaient pas annuels comme à présent. Pour un homme militant et ardent comme je l'étais, c'était un grand malheur. Dans l'âge de la sève et de l'audace, il m'aurait fallu quelque ministre aussi hardi que moi, pour prendre mon parti, c'est-à-dire pour me faire de grands ouvrages et me donner les occasions de les montrer souvent. C'est le contraire qui arriva. A la fin d'un de ces salons, en 1827, car on renouvelait les tableaux à mesure que l'exposition se prolongeait, j'exposai un tableau de *Sardanapale* qui fut comme ma retraite de Moscou, si l'on peut comparer les petites choses aux grandes. J'avais eu quelques succès à ce salon, qui avait duré, je crois, six mois. Cette pièce, qui arrivait la dernière, et qui parut excentrique, souleva l'indignation feinte ou réelle de mes amis et de mes ennemis. Je devins l'abomination de la peinture. Il fallait me refuser l'eau et le sel. M. Sosthènes de la Rochefoucauld, qui était alors chargé des beaux-arts, me fit venir un beau jour; et moi qui me figurais, sur cette invitation, qu'il allait me donner quelque bonne nouvelle et me commander au moins un tableau! J'entre: en homme aimable, car il faut lui rendre cette justice, il s'y prit avec douceur et comme il put, car il n'avait pas de facilité, pour me faire entendre que je ne pouvais décidément avoir raison contre tout le monde, et que, si je voulais avoir part aux faveurs du gouvernement, il fallait enfin changer de manière. A ce dénoûment, je l'arrête court en lui disant que je ne pouvais m'empêcher d'être de mon opinion, quand la terre et les étoiles seraient de l'autre côté; et comme il s'apprêtait à m'attaquer par le raisonnement, je lui fis un grand salut et sortis de son cabinet, le laissant plus interdit que moi. J'étais, au contraire, enchanté de moi-même, et mon *Sardanapale* me parut, à partir de ce moment, très supérieur à ce que j'avais cru.

'La suite de cette action fut déplorable: plus de tableaux achetés, plus de commandes pendant plus de cinq ans. Il fallut une révolution comme celle de 1830 pour donner à d'autres idées. Vous jugerez ce que fut pour moi, sans parler de la question d'argent, un pareil chômage, dans un moment où je me sentais capable de couvrir de peintures une ville entière. Non pas que cela ait refroidi mon ardeur; mais il y eut beaucoup de temps perdu en petites choses, et c'était le temps le plus précieux.' (Extrait du cahier du manuscrit).

Appendix 2:
'Palette pour la Mort de Sardanapale'
(from Piot, *Les Palettes de Delacroix*,
Paris, 1931, pp. 75-7)

Ce fut en peignant le *Sardanapale* que Delacroix fit le plus d'efforts pour arriver à l'éclat et à la variété de la couleur. Il aimait, dès lors, et il a toujours aimé la manière des maîtres décorateurs: et l'avantage de pouvoir user de toutes les couleurs le charmait.

Aussi a t il cherché tous les moyens d'allier à souhait la peinture en détrempe à la peinture à l'huile. Il regrettait encore vers la fin de sa vie de n'avoir pas encore réalisé ce moyen, à ses yeux, infaillible, d'assurer en même temps à sa peinture les tons de la détrempe et du pastel.

C'était tenter presque l'impossible, car la peinture à l'huile rembrunit beaucoup cette blonde préparation à la détrempe. La combinaison des tons de la *Mort de Sardanapale* fut une des plus sérieuses combinaisons de couleurs de Delacroix.

Son tableau une fois ébauché à la détrempe, le maître fit une suite d'études partielles au pastel, d'après nature.

Le pastel étant une autre détrempe pour la blondeur et la fraîcheur de la coloration, il se trouvait ainsi prémuni par ses pastels et à mesure que le tableau avançait, contre les fâcheux changements que la peinture à l'huile pouvait faire subir à sa détrempe. Il se préoccupait beaucoup, ai-je dit, des peintres décorateurs de théâtre; particulièrement de Cicéri, et la multiplicité des tons de pastel l'habituait à la même variété des tons dans la peinture à l'huile.

Ces procédés, Delacroix les avait indiqués, non pas précisément d'après son grand tableau original exposé au Salon de 1827, mais d'après une petite répétition faite bien plus tard.

Cette petite répétition, ainsi qu'une suite d'études à l'huile et de même dimension que les figures du tableau primitif de *Sardanapale* M. Delacroix les avait faites pour lui-même avant de les céder, en 1847 à M. Wilson. Ce tableau, son enfant malheureux et gâté, qui lui a donné tant de difficultés et de tourments, causé tant d'injures et rapporté si peu d'argent, M. Delacroix ne put se résoudre à s'en séparer qu'après avoir gardé tous les éléments possibles et bien laborieux de souvenir. Il

croyait l'avoir peint dans les meilleures conditions imaginables de conservation, mais l'action des couleurs à l'huile sur l'ébauche en détrempe et l'humidité du lieu où l'avait placé M. Wilson dans son château de La Brie le détériorèrent gravement.

L'effet du dessous, l'état des glacis et les repeints rendaient ce tableau pitoyable ; et, chose à remarquer, le vert de Chelles, employé pour trois draperies et mis en frottis sur un ton de bleu de Prusse et blanc restait presque intact, n'ayant seulement qu'un peu noirci. Ce fut encore à moi qu'incomba la tâche de cette difficile et scabreuse restauration. Le Maître vint me voir souvent à l'oeuvre pour me faire ses remarques et ses recommandations.

Appendix 3: The Sketches

RF 5 278 r. 25.5 x 33.8 cm., pencil. Paris, Louvre. For a discussion of this earliest sketch for the painting, see the first two paragraphs of Chapter 2 [12].

RF 5 278 v., pen and pencil. Delacroix scribbled the following notes: 'tranquill' io sono fra poco' and 'gens effrayés ou résistants dans le fond' and 'la mitre jaune (?) comme les lions au fond et jouants'. The latter phrase – as deciphered here – shows Delacroix's design of matching the yellow color of the king's mitre to that of the lions (which he apparently never included in the painting). In this case he wished color to serve neither decoratively nor expressively, but as a repeated element unifying the composition [13].

RF 6 860. 23.8 x 30.0 cm., pencil and sepia wash. Paris, Louvre. The sketchily indicated lions (beside a horse and a wolf) substantiate Delacroix's interest in lions alluded to in his notes on Sketch 13 [14].

RF 10 204r. 14.1 x 19.4 cm., pencil. Paris, Louvre. This sketch, probably associated with the *Sardanapalus*, shows a small figure straining to the left like the Negro stabbing the horse; and there is, in fact, the large head of a terrified horse at his left. It is striking that two victims may be associated here; for the woman reclining in a voluptuous pose but with a tormented expression on her face wears a necklace perhaps prefiguring the rope around the suicide Aischeh's neck [15].

Drawing from the L. Riesener Collection, Kunsthalle, Bremen, 21.6 x 33.1 cm., pencil. Another figure suggesting the Ethiopian (he has a similar 'cap-line') appears here, but his stance – unlike the Ethiopian's – resembles an Arab's thrusting a spear at a lion. There are studies of writhing nudes in several positions, one tilted like the nude at the foot of the bed; and there are studies for the Ethiopian's bent leg [16].

Drawing from the L. Riesener Collection, Kunsthalle, Bremen, 22.4 x 34.5 cm., pencil and pen (brown ink). Here, as in Sketch 15, we find a figure – the central one lunging to the left – similar to the stabbing Ethiopian, above all in its combination of extended and bent arms, but also in the 'cap-line', the clenched right fist, and the completely bent right (later left) leg. Below the right fist an arc suggests the path of a stabbing movement and corresponds to the curve along the horse's head and body in the final version [17].

RF 9 150/13. 9.8 x 16.2 cm., pencil. Paris, Louvre. The powerful Michelangelesque arms resemble those in Sketch 14. More interesting is the 'abstract' diagram of the interplay of forces between the stabbing man and the horse. The diagram reveals the artist's sensitivity to the relation between the dynamic figures and their formal ground, as the horse is drawn in large round forms set in contact with the rectilinear base-line [18].

RF 5 276. 21.2 x 32.2 cm., pencil. Paris, Louvre. This is still close to our first Sketch 12. But Sardanapalus' expression with his large intense eyes has become more ferocious, suggesting one of Delacroix's fierce Arab huntsmen. The man stabbing the horse stands out clearly, and his dark athletic body with its bent leg set on a straight base as in Sketch 18 resembles the dynamic postures of the nudes in Michelangelo's Sistine Ceiling. Delacroix's annotation 'Mémoires du Vénitien Casanova' introduces a sensual note into the midst of the ferocity [19]. See also note 16 below.

No. 48–323v. 23.0 x 19.0 cm., pencil. Princeton University, Art Museum. Here Delacroix continues the explorations of the square step-forms to the right and left of the bed already introduced in Sketches 12 and 18. The hint of a bas-relief grouping suggests comparison with neoclassical composition, but the energy and excitement of some of the figures provide a powerful Baroque quality to the sketch [20].

RF 5 274r. 25.8 x 32.4 cm., pen, watercolor and pencil. Paris, Louvre. Note the dynamic quality of 'inanimate' objects such as the garments and bedsheets that flow down, spilling into the foreground jewelry [21].

RF 5 274v. Charcoal. This sketch recalls the abstraction of Sketch 18, since the lowest figure is reduced to an elemental line pattern, showing the thrust of the arms and head [22].

Drawing in the Bonnat Museum, Bayonne (Robaut no. 169). 28.0 x 40.0 cm., pen and pencil. Striking is the presence of the smoke from the burning pyre at the foot of the bed; in the painting this will disappear from the foreground and be replaced by unlighted wood blocks. A subtle and important substitution is introduced here, one that the artist will often use again: for the dramatic fire and smoke he substitutes the painterly quality of jewelry rich in color [23].

RF 2 488. 81.0 x 100 cm., oil on canvas. Paris, Louvre. The almost rude simplicity of Sardanapalus' bed (which is still not a big and luxuriant one as in the painting) here becomes elaborated with the addition of the elephant head at the corner. We note the absence in the background of Aischeh hanging herself [24]. See also Chapter 2 and note 16 below.

RF 5 277r. 20.5 x 31.4 cm., pen and wash. Paris, Louvre. Sardanapalus' expression is still darkly brooding, but he no longer looks down the diagonal as in the earlier sketches and his beard is full and dark as in the painting. The nude writhing in maenadic fury will become the woman at the far end of the bed seen from the back [25].

RF 5 277v. Pencil. The soldier stabbing himself in the painting makes his appearance here, but a number of the vigorously turning and gesticulating figures such as the horse-stabber will be modified or disappear in the painting [26].

RF 6 760. 13.7 x 15.3 cm., pencil. Paris, Louvre. This late sketch contains many details similar to those in the painting, and allows us to make out the architecture above Sardanapalus' head more clearly than in the painting [27].

RF 29 665. 44.0 x 58.0 cm., pastel. Paris, Louvre. The sketch of the nude at the top exquisitely describes the sensuously diaphanous quality of her clothing through which her skin can be discerned [28, 28A].

RF 29 666. 40.0 x 27.0 cm., pastel. Paris, Louvre. We are especially struck by the study of the twisting nude being stabbed in the neck as she fetchingly exposes her breast and buttocks. The energetic posture reminds one of the figures of Rubens, or even of a drawing of a nude by Lebrun in the Louvre, illustrated in the catalogue of the Lebrun exhibition held at Versailles in 1963, no. 62 [29].

RF 29 667. 30.0 x 23.5 cm., pastel. Paris, Louvre. This famous and often reproduced study of a *babouche* was realized with a hatching technique anticipating later experiments of the artist [30].

Notes

1. See Nietzsche, *Werke*, vol. XI, p. 8.

2. For the *Sardanapalus* – as for some later paintings – Delacroix consulted the famous stage designer Cicéri. See Piot, *Les Palettes de Delacroix*, Paris, 1931, p. 75 cited in Appendix 2.

3. See Achille Piron, *Eugène Delacroix, sa vie et ses oeuvres*, Paris, 1865, p. 70. This text is cited in Appendix 1.

4. See Leslie A. Marchand, *Byron, A Biography*, New York, 1957, vol. II, p. 897.

5. In Book II, pp. 78 ff, in the edition of 1604.

6. Cf. Samuel C. Chew, *The Dramas of Lord Byron*, Göttingen, 1915; and Beatrice Farwell, 'The Sources of Delacroix's *Death of Sardanapalus*', *Art Bulletin*, March 1958, pp. 66–71.

7. See Marcelle Wahl, 'La Mort de Sardanapale' in *Le Mouvement dans la Peinture*, Paris, 1955.

8. See Lee Johnson, 'The Etruscan Sources of Delacroix's *Death of Sardanapalus*', *Art Bulletin*, December 1960, pp. 296–300.

9. Cf. G. P. Mras, *Delacroix's Theory of Art*, Princeton, 1966, p. 107, which simultaneously criticizes the *Chios* and the *Sardanapalus* as 'clearly' lacking 'compositional and psychological unity'.

10. Frank Trapp, *The Attainment of Delacroix*, Baltimore, 1970, pp. 88–9.

11. See Lionello Venturi, *Peintres Modernes*, Paris, 1941, p. 119: '. . . le maniérisme se montre soit dans les formes des corps, soit dans les couleurs – le rose du lit est de la teinte et non de la couleur – soit surtout dans la composition qui voudrait conquérir l'espace en profondeur et n'arrive qu'à accumuler les chairs.'

12. For a discussion of the artist's later treatment of pearls, see the author's book, *The Murals of Eugène Delacroix at Saint-Sulpice*, New York, 1967. Study of such details can often provide insight into larger questions of the artist's style.

13. See Appendix 2.

14. Delacroix already approached a Titian-like glaze in the flesh of his figures for the *Chios*, to judge from X-rays taken by Madeleine Hours, 'Quelques tableaux de Delacroix sous les rayons X', *Bulletin du Laboratoire du Musée du Louvre*, no. 8, 1963, p. 6: '. . . sur l'image radio-

graphique des deux prisonniers assis, les documents [X-ray photos] obtenus ont une profondeur et un modelé d'une subtilité incomparable, toute en nuance, avec des contours doux, une infinité de gris dus aux nombreuses reprises; cette technique donne naissance à des documents qui ne sont pas sans rapport avec ceux obtenus d'après les oeuvres du Titien.' Similar results were apparently obtained for the head of Sardanapalus in the oil sketch for the painting, to judge from unpublished X-rays at the laboratory. Up to now the *Sardanapalus* itself has not been X-rayed.

15. Cf. Spector, op. cit. (1967) for another example. For bibliographies of the sketches in the Louvre, see Sérullaz, *Mémorial*, Paris, 1963.

16. Sketch 19 contains the annotation 'Mémoires du Vénitien Casanova', which provides us with a date post-quem for the sketch, since the memoirs were translated into French in 1826. Sketch 23 is called by Robaut (no. 169) the 'première pensée du tableau de 1827', which seems wrong to me (unless he meant that this is the first full-scale composition, which it is), since a number of elements are further realized and closer to the painting than in the sketches we've already considered: Sardanapalus' arms (one of which is covered now with drapery) and his posture, the dominance of the bed and the presence of the woman lying across it, as well as the distribution of figures such as the man and the horse about the bed, all move toward the final solution. On the other hand the diagonal glance of Sardanapalus will turn parallel to the frame in the painting where he is shown as more contemplative (the clenched fist of the sketch becoming an open hand supporting his head), the stabbing of the nude woman will be shifted from the bed to the foreground so as to correspond to the stabbing of the horse, and the figures looking down as from the balcony of a theatre (reminding one of the *Heliodorus* of Saint-Sulpice, Paris) will be replaced by clouds of smoke reminiscent of the hell fires of the earlier *Dante and Virgil*. The author has followed the evolution of the figures from the early expressive drawings to the tempered complexity of the final murals at Saint-Sulpice. See Spector, op. cit. (1967). The important oil sketch 24 in the Louvre has been considered to date to the end of 1826 by Moreau, *Delacroix*, 1873, p. 170. Delacroix liked this sketch well enough to place it (probably – according to Joubin, *Journal*, notes, III, 372 – in 1843) among the works listed on the occasion of his candidacy for the Institut, and to write in his *Journal* on 4 February 1849 'Revu dans le cabinet de Rivet l'esquisse du *Sardanapale* qui ne m'a pas deplu malgré quelques excentricités'. Lee Johnson correctly identifies this sketch with the one referred to by Rivet as quoted by Piron (see

Appendix 1), but he errs, I believe, in regarding it – as claimed by Rivet – to have been painted by Delacroix right after reading Byron's play. M. Sérullaz, *Mémorial*, no. 100, rightly places this sketch later than a number of Delacroix's explanatory studies of the theme (but I cannot agree with him that it belongs after the pastel drawings). This painting is closely connected to the Bonnat sketch in such details as Sardanapalus' posture and the vague blur of fire and smoke in the foreground. But there are important differences: the woman below Sardanapalus disappears, while the nude below her expands to fill the side of the bed, the nude in the right foreground is pressed against the foot of the bed, and the stabbed woman – here virtually decapitated – is added to the foreground for the first time.

17. It seems to me that Lee Johnson exaggerates the importance of Delacroix's phrase on the sketch 'etrusques de toutes facons' [sic] and certain formal indications in his attempt to define the main source of the composition as 'Etruscan'. See Johnson, op. cit.; and F. Trapp's criticism in his book, op. cit. Among many possible sources for accessories of the *Sardanapalus*, Egypt has been proposed by Philippe Jullian as an alternative to Mesopotamia, which was not excavated until the 1850s; but this interesting speculation is not demonstrated. See Jullian, 'Delacroix et le thème de Sardanapale', *Connaissance des Arts*, no. 34, April 1963, pp. 82-9. Hugh Honour, noting that George Dennis, *The Cities and Cemeteries of Etruria*, 1848, p. lxviii, links early Etruscan sculpture with 'the Egyptian which also has Babylonian analogies', has kindly suggested to me that (assuming Dennis received this idea from a sufficiently earlier source) this link might bear on the iconography of the *Sardanapalus*. The Englishman John Martin's *Sardanapalus* of 1827 naturally comes to mind in connection with such an investigation. With regard to the Rubensian element of the painting, the figure at the foot of the bed has been convincingly derived from Rubens's *Disembarkation of Marie de Medici at Marseilles* by Barbara E. White, 'Delacroix's Painted Copies after Rubens', *Art Bulletin*, vol. xlix, 1967, pp. 37-51; and one may also note that the elephant strongly suggests the caryatid figures on the ship in the same painting of Rubens.

18. See Piot, *Les Palettes de Delacroix*, Paris, 1931, pp. 75-7, cited in Appendix 2.

19. Delacroix's drawings of details often reveal his painterly intentions; thus, in sketch 27 the strongly defined pencil marks for the jewelry adorning Sardanapalus and the left arm of the nude stretched beneath him correspond to the points of application of opaque white pigments, to judge from the painting itself and from X-rays of the *reprise*.

20. See the *Journal*, III, Supplement, p. 434.

21. Delacroix's letter to Haro is dated 29 October 1827.

22. The reworkings over the ground tones referred to here would probably have resulted in the kind of blurred X-rays made from the *Chios*. For the X-rays, see note 14. Judging from Delacroix's comments on the 'état deplorable' of the original on 1 September 1849, Andrieu's restoration occurred after this date. On Andrieu's restoration, see also Henriette Bessis, 'Les Décorations murales de Pierre Andrieu', *Gazette des Beaux-Arts*, March 1967, p. 184.

23. Book III, chapter 11. (N.B. Modern Library ed. trans. Cf. Mitford's on p. 69.)

24. Cicero, *Tusculanae disputationes*, vol. V, section XXXV; Ovid, *Ibis*, no. 312.

25. See Ennio Quirino Visconti, 'Il Museo Pio Clementino', *Le Opere*, vol. II, pp. 268–9, Milan, 1819. I wish to thank Hugh Honour for calling my attention to Visconti's text and engraving.

26. See Ivan Dujcev, *The Miniatures of the Chronicle of Manasse*, Sofia, 1963, no. 10. Mr Orville J. Rothrock of the Princeton University Print Collection first called my attention to this work. Professor Weitzmann, the eminent Byzantinist at Princeton, in a long illuminating conversation with me commented on the theme in Byzantine art.

27. In the sense of gluttony described by Aristotle, *Nicomachean Ethics*, III, Chapter 11, where he speaks of 'belly-gods'.

28. For Brant, see Panofsky, *Hercules am Scheidewege*, p. 97, note 1; for Filarete, see Edgar Zilsel, *Die Entstehung des Geniebegriffes*, p. 155.

29. See Hugnet, *Dictionnaire de la langue française du 16ème siècle*.

30. See the illustration in F. W. H. Hollstein, *Dutch and Flemish Etchings, Engravings and Woodcuts* (1450–1700), Amsterdam, 1949–54.

31. See Bizaro, *Rerum Persicarum Historia*, Frankfurt, 1601, p. 1: '. . . ad Sardanapalum usque, in summa potentia atque gloria floruit, ditiusque omnium indicio propagari potuisset, nisi regis inertia ac effeminatus animus regni nervum incidisset'.

32. Daniel Lingelbach's play of 1699, *Sardanapalus*, follows the classical sources. See Farwell, op. cit., note 6.

33. See Koopmans, *Disputatio Historico-Critico de Sardanapalo . . .*, Amsterdam, 1819, p. 2: 'Vetus est opinio Sardanapalum Assyriae regem luxuria difluxisse, aetatem egisse in otio deliciis que, ac, velute sexu mutato, virtutem, quae virem decet, perdidisse effeminata mollitie.'

34. See Hector Berlioz, *Mémoires*, introduction by Pierre Citron, vol. I, p. 184–5, Paris 1969. Another cantata, by one 'Gail' performed at the

Académie des Beaux-Arts in 1830, is listed in 'Les Membres de l'Académie des Beaux-Arts', *Archives de l'art français*, n.s., t. IV, pp. 149-243, Paris, 1910.

35. See J. Seznec, *John Martin en France*, Oxford, 1964 pp. 44-6, for a discussion of the Martin *Fall of Nineveh* and Delacroix's *Death of Sardanapalus*.

36. See Gertrud Berthold, *Cézanne und die alten Meister*, 123, no. 242.

37. See T. Gautier, *Roman de la momie*, III, Paris, 1853.

38. Cf. Trapp, op. cit.

39. See also Gautier's preface to *Mlle de Maupin*, 1835-6: 'Je suis aussi las que si j'avais éxécuté toutes les prodigieusités de Sardanapale . . .' Later in the century Villiers de l'Isle-Adam's *Axel* contains many parallels to the dandy.

40. See G. H. Hamilton, 'Eugène Delacroix and Lord Byron', *Gazette des Beaux-Arts*, XXIII, February 1943, pp. 99-110, and P. van Tieghem, *Le Romantisme dans la littérature européenne*, Paris, 1948, p. 182.

41. See Louis Dimier, *Histoire de la Peinture française au XIXe siècle*, Paris, 1914, p. 74.

42. See Hamilton, op. cit., 99-110.

43. See Piron, op. cit., p. 154. For an interesting comparison of the 'melancholy genius' of the Renaissance and of Romanticism, see J. A. Emmens's review of R. and M. Wittkower, *Born Under Saturn* (New York, 1963), in *Art Bulletin*, September 1971, esp. p. 428: 'With the appearance of Abrams's brilliant study *The Mirror and the Lamp*, it has become more apparent than ever that the attitude of the Romantic artist towards himself and his art was drastically different from that of his predecessors towards themselves and their art. And it was the Romantic artist's self-image that formed the foundation for the idea of the "modern artist".'

44. See van Tieghem, ibid.

45. For an English translation of Sainte-Beuve's essay, originally published in 1830, see Eugene Weber, *Paths to the Present*, New York, 1963, pp. 130-34.

46. Delacroix knew another 'Myrrha' - the incestuous daughter from Book X of Ovid's *Metamorphoses*; for in the early 1820s he included her name among other figures from the *Metamorphoses* on a list of painting projects. See the album at the Louvre RF 23.357, inside front cover. A. Joubin, 'Études sur Eugène Delacroix', *Gazette des Beaux-Arts*, March 1927, p. 168, rightly dates the album to 1821-4, but incorrectly copied the list to read 'Leda/Myrrha (Acis et Galatée) . . .'; of course

Myrrha had nothing to do with Acis and Galatea. The list should read 'Leda/Myrrha/Polyphème (Acis et Galatée) . . .'

47. See Farwell, op. cit. The elephant figures at the corners of the bed which have also attracted Miss Farwell's attention will be discussed below, note 56.

48. For the earlier views, see Jean Guiffrey, *Gazette des Beaux-Arts*, 1921, p. 196, and Raymond Escholier, *Delacroix*, I, 1926, p. 222.

49. For Delacroix's references to volumes II and III of Hamilton's collection, probably in the edition of Naples, 1766–7, *Antiquités étrusques, grecques et romaines, tirées du cabinet de M. Hamilton*, see the albums at the Cabinet des Dessins RF 6.736, p. 61r and RF 9.141, pp. 1r and 6.

50. See Johnson, op. cit., and note 17 above.

51. Delacroix could have seen such figures in many places, including vol. II of Hamilton's collection, (plate 51), 'Fête de Bacchus' with the text 'L'homme mange seul, c'étoit l'usage général de la haute Antiquité; les Grecs l'appelloient *Monophagie*.'

52. See G. H. Hamilton, 'Delacroix, Byron and the English Illustrators', *Gazette des Beaux-Arts*, July-December 1949, p. 278.

53. See the *Journal*, III, p. 353.

54. See Johnson, op. cit.

55. See the important article by Barbara E. White, 'Delacroix's Painted Copies after Rubens', *Art Bulletin*, 1967, pp. 27–51.

56. Miss Farwell has sought far and wide for sources of the elephant as well as for the massacre, and overlooked a number of well-known images of elephants any of which Delacroix might have seen and connected with his painting. See Farwell, op. cit., pp. 70–71. The age-old fascination for the elephant in Europe is easily documented: a Greco-Bactrian silver dish of the third century B.C. in the Hermitage; numerous Roman coins and ivories; Bishop Ursus's throne (1078–89) at Canosa Cathedral; French Romanesque capitals such as at Saint-Pierre in Aulnaye de Saintonge (1119–35); on Byzantine silks; and on innumerable eighteenth-century ceramics, such as those from Meissen. More interesting to us are the many versions in painting and tapestry of Le Brun's *Entry of Alexander into Babylon* with its prominent elephant on parade, a subject treated even in Italy during the eighteenth century by G. Diziani and F. Fontebasso. See the excellent catalogue of the exhibition of eighteenth-century Venetian paintings at the Orangerie in October 1971 prepared by M. Pierre Rosenberg. An important survey of the elephant in Napoleonic and earlier iconography is offered in W. S. Heckscher, 'Bernini's Elephant and Obelisk', *Art Bulletin*, XXIX, September 1947, pp. 155–82. Robert

Rosenblum's valuable *Transformations in Late Eighteenth Century Art*, Princeton, 1969, p. 133 and note, refers to post-Napoleonic elephant imagery.

57. The point that the 'three unities' of dramatic theory could not be translated into the criticism of painting without major distortions on both sides has been well made by Rensselaer Lee, *Ut Pictura Poesis*, New York, 1967, pp. 64-5.

58. On neoclassicism, see the excellent volumes, with bibliographies, of Hugh Honour, *Neo-classicism*, London, 1970, and of R. Rosenblum, op. cit.

59. This painting, as Frank Trapp, op. cit., has remarked, may be a discreet celebration of the first Bourbon king of France.

60. Charles Gabet, *Dictionnaire des Artistes de l'Ecole française au XIXe siècle*, Paris, 1831, mentions the *Christ in the Garden of Olives*, but ignores the *Sardanapalus*!

61. Stendhal wrote a 'Literary Letter from Paris', *Athenaeum*, 28 May 1828.

62. See Hugo's letter to Victor Pavie of 3 April 1829.

63. Information kindly supplied by Mr Haavard Rostrup of Ny Carlsberg Glyptotek, Copenhagen.

64. The sketch was exhibited in 1862 and 1864 at the same Galerie Martinet, in 1885 at the Ecole des Beaux-Arts, in 1928 at Copenhagen, in 1930 at the Musée des Arts Décoratifs and the Louvre, in 1936 at the Petit-Palais, in 1939 in Belgrade, in 1951 at Delacroix's atelier, in 1956 in Agen, Grenoble and Nancy, in 1959 at the Tate Gallery, London, and in 1964 in Bremen and Edinburgh; and the *reprise* of 1844 was exhibited in 1885 at the Ecole des Beaux-Arts, and in 1889 at the Paris Centennial Exhibition.

65. See Gustave Planche, *Portraits d'Artistes*, Paris, 1853, vol. II, pp. 49-61.

66. See Schneider, 'Through the Louvre with Barnett Newman', *Art News*, vol. 68, no. 4, Summer 1969, p. 70.

67. Delacroix's later work – even his religious paintings – nevertheless continued to be abused by prejudiced critics for its violence and the pagan sensualism of its colors. See Spector, op. cit., (1967).

68. Robaut's annotations on a copy of his catalogue of Delacroix's work in the Bibliothèque Nationale contains some revealing information: 'On a dit qu'un des jours où Delacroix cherchait sa composition, Poterlet travaillait près de lui – et à un moment de découragement, Delacroix dit a son ami: "Eh bien, cherches-moi ça sur une toile et fais comme tu

l'entends." Poterlet aurait alors exécuté la toile dont je donne ci-contre les différences principales . . .' Robaut noted the following differences between the two versions, without expressing much interest in what he considered a 'heavy-handed sketch': the woman in the center (Aischeh) has her head raised, not lowered; there is a nude covering her head protectively with her arms at the right side of the bed; and, the man at the right of the bed has two, not one arm extended as in Delacroix's painting. Robaut overlooked the strong possibility that these three differences may have suggested the corresponding figures in Delacroix's painting; for Poterlet's sketch is the only place before the final painting where they appear. Thus, the nude covering her head with her arms may have suggested the woman at the left of the bed covering her head with drapery, as the man at the right may have suggested the figure extending one arm over his head. Above all Aischeh may have been born of the mediocre sketch by Poterlet with its central figure of a nude woman. Delacroix has of course transformed these scattered hints into a richly interlocking composition, with an intensity of feeling and an extraordinary expression absent in his 'model'. Poterlet's work won the praise of Delacroix – see his letter to Poterlet of 9 August 1827, and his will, mentioning some sketches of Poterlet that he had kept up to his death; and not only did the artists visit England together in 1825, but they collaborated precisely in the period of the *Sardanapalus* – see Delacroix's letter to Louis Schwiter, 21 November 1827. Delacroix's *Christ in the Garden of Olives* of 1827 was, according to a note in the *Journal* (undated; probably 1843) 'begun by Poterlet and finished by me' (Poterlet actually made a lithograph of Delacroix's painting to illustrate Jal's *Salon of 1827*). Poterlet's influence does not of course exclude that of others such as Monsieur Auguste's on the horse or on the Oriental accessories – see Johnson, op. cit.

69. For Lord Ure and Abbé Stialité see pp. 48 and 50 in RF 9140, an album of Saint-Sylvestre that dates from as early as 31 December 1817.

70. The choice of Achilles as a companion to his own name was not unique for the artist: the *Journal* is strewn with references to the Greek hero, and in praising Napoleon he could think of nothing higher than to call him 'as poetic as Achilles'. See the essay on Gros, published in 1848, in Piron, op. cit.

71. See the essay on Gros in Piron, op. cit., p. 228.

72. RF 9146.

73. See Charles Cournault's letter, published in *L'Art*, 1883, p. 97, recounting Delacroix's visit to a harem, in which he said: 'La femme dans

le gynécée s'occupant de ses enfants, filant la laine ou brodant de merveilleux tissus, c'est la femme comme je la comprends!'

74. A typical remark was made to his friend Soulier, in a letter of 19 May 1853: 'As for me, I am obliged to employ a great economy if I want to paint much.' This pattern seems to imply emotional commitments much larger than financial or energetic, and to suggest the sort of interpretation Freud made of Leonardo's involvement with budget accounts. See Spector, *The Aesthetics of Freud: A Study of Art and Psychoanalysis*, New York and London, 1973.

75. I owe the suggestion of an Italian helper to my colleague Professor Remigio Pane. In connection with Delacroix's belief in an Italian lack of inhibition, there occurs in his letter to Pierret of 1 August 1825, the striking phrase '. . . l'abandon de l'Italie irait mieux à mon esprit que la netteté de l'Angleterre.' Nevertheless, he visited England, not Italy.

76. Cited by Raymond Escholier, *Eugène Delacroix*, Paris, 1960, p. 49.

77. He expressed this fear at the age of 26, when he failed to perform sexually with his model Hélène, as recorded in the *Journal* on 7 April 1824. Parenthetically, on 20 April he notes that Hélène refused *him* with the excuse of a 'headache'. If her excuse was not necessitated by her own biological needs, it is possible that Hélène sensed a rejection in Delacroix's failure (cf. below for an analogous experience with Elisabeth Boulanger).

78. See Escholier, op. cit., p. 253. In a later book, *Delacroix et les Femmes*, Paris 1963, pp. 95–6, Escholier repeated the point: '. . . les facultés amoureuses de Delacroix avaient des limites, et ces limites étaient vite atteintes . . .' In a grand effort to prove that Delacroix was not – as Baudelaire had presented him – misogynous, Escholier argues for a dimension of the artist's sentimental life heretofore veiled in mystery (p. 36): 'Nous allons voir, preuves en main, combien Baudelaire s'égarait. Delacroix eut un coeur de chair, une âme tendre et frémissante, délicieusement ouverte à l'amitie feminine et à l'amour. Seulement, cet esprit fier et délicat avait le goût du mystère; volontiers mystificateur et toujours diplomate . . .' According to Escholier, Delacroix's main love relationship was with the mystery woman who signed her letters to him 'Consuelo' (*consolatrice*). Escholier shows that Consuelo was Madame de Forget, one of Delacroix's cousins.

79. See the *Journal*, I, p. 445; also the beginning of Chapter 4, above, where the Romantics' fascination with immersion in the mass is discussed.

80. For the letter to Beyle (Stendhal) of 14 September 1831, see Prosper Mérimée, *Correspondance Générale*: 'Arrivé chez Leriche . . . nous avons fait exécuter exercices de gymnastique par six filles in naturalibus et le

but c'était la contenance d'un chacun . . . Mais notre ami de la + était frénétique. Il haletait, pantelait et voulait les embrocher toutes à la fois. Sans le respect qu'on doit au papier, je vous dirais de drôles de choses de son enthousiasme érotique.'

81. The links between the theme of assassination and the orgiastic setting of the *Sardanapalus* can be established even for such scenes as *The Assassination of the Bishop of Liège* of 1831, a painting not obviously linked to an orgy. Delacroix was attracted to the theme as early as 1827, and he borrowed the subject from Walter Scott's *Quentin Durward*, specifically from a chapter called 'l'Orgie' in the French translation of 1824, as noted by Sérullaz, *Mémorial*, no. 136; moreover, M. Sérullaz, op. cit., no. 139, observes that the verso of the first sketch (RF 5275) for the painting perhaps contains a study for the *Sardanapalus* which would reinforce the connection of the assassination and the orgiastic suicide and massacre.

82. Escholier has claimed (*Delacroix et les Femmes*, p. 117) that Delacroix was capable of and had, in the period 1834-44, a complete love relationship with Mme de Forget (see note 78 above). But why, then, he wonders, did this relationship not result in a frank liaison, even marriage after the death of Monsieur Forget, her husband? Escholier's explanation reveals little insight into the artist's motivations: 'Quelles raisons impérieuses les détournèrent d'unir à jamais leurs deux existences pourtant déjà si mêlées? On doit supposer que Delacroix qui était un bizarre alliage de misanthrope et de dandy, d'Alceste et de Philinte, appréhendait pour son art et pour sa santé, condition même de son art, les exigences d'une femme du monde, qui l'eût voulu conduire de réception en réception.' Can the fact that they were cousins have inhibited their consummating a marriage? Possibly – even though no one has directly raised the issue; but even if this were so, it would hardly affect my view of Delacroix's psychology. The very impossibility of fulfillment would have made his cousin all the more attractive.

83. See the *Journal*, I, p. 85, 26 April 1824.

84. See the *Correspondance*, I, p. 215, 26 April 1828.

85. Alfred de Vigny, *Chatterton*, Act I, scene 5. It is significant that the Quaker who addresses these words to Chatterton intended to *praise* the discouraged poet for suffering a 'malady' that set him apart from others: 'Je t'aime, parce que je devine que le monde te hait. Une âme contemplative est à charge à tous les désoeuvrés remuants qui couvrent la terre: l'imagination et le recueillement sont deux maladies dont personne n'a pitié!'

List of Illustrations

Color Plate: *The Death of Sardanapalus* by Eugène Delacroix, 1827–28. Oil on canvas, 3.95 x 4.95 metres. Paris, Musée du Louvre. (Photo: Telaroi-Giraudon.)

18. Sketch for *The Death of Sardanapalus* by Delacroix, 1827–8. Pencil. Paris, Cabinet des Dessins, Musée du Louvre (Photo: Museum.)

19. Sketch for *The Death of Sardanapalus* by Delacroix, 1827–8. Pencil. Paris, Cabinet des Dessins, Musée du Louvre (Photo: Museum.)

20. Sketch for *The Death of Sardanapalus* by Delacroix, 1827–8. Pencil. Princeton University, Museum of Art (Photo: Museum.)

21. Sketch for *The Death of Sardanapalus* by Delacroix, 1827–8. Pen, watercolor and pencil. Paris, Cabinet des Dessins, Musée du Louvre (Photo: Museum.)

22. Sketch for *The Death of Sardanapalus* by Delacroix, 1827–8. Charcoal. Paris, Cabinet des Dessins, Musée du Louvre (Photo: Museum.)

23. Sketch for *The Death of Sardanapalus* by Delacroix, 1827–8. Pen and pencil. Bayonne, Musée Bonnat (Photo: Archives.)

24. Sketch for *The Death of Sardanapalus* by Delacroix, 1827–8. Oil on canvas. Paris, Musée du Louvre (Photo: Archives.)

24A. Detail of 24 (Photo: Giraudon.)

25. Sketch for *The Death of Sardanapalus* by Delacroix, 1827–8. Pen and wash. Paris, Cabinet des Dessins, Musée du Louvre (Photo: Museum.)

26. Sketch for *The Death of Sardanapalus* by Delacroix, 1827–8. Pencil. Paris, Cabinet des Dessins, Musée du Louvre (Photo: Museum.)

27. Sketch for *The Death of Sardanapalus* by Delacroix, 1827–8. Pencil. Paris, Cabinet des Dessins, Musée du Louvre (Photo: Museum.)

28. Sketch for *The Death of Sardanapalus* by Delacroix, 1827–8. Pastel. Paris, Cabinet des Dessins, Musée du Louvre (Photo: Museum.)

28A. Detail of 28 (Photo: Museum.)

29. Sketch for *The Death of Sardanapalus* by Delacroix, 1827–8. Pastel. Paris, Cabinet des Dessins, Musée du Louvre (Photo: Museum.)

30. Sketch for *The Death of Sardanapalus* by Delacroix, 1827–8. Pastel. Cabinet des Dessins, Musée du Louvre (Photo: Museum.)

31. 'Sardanapalus', engraving of an antique statue in the Vatican Museum, from E. Q. Visconti: 'Il Museo Pio Clementino', *Le Opere*, 1819.

32. Detail of *The Death of Sardanapalus* by Delacroix, 1827–8.

33. *The Death of Sardanapalus* from the *Chronicle of Manasse*, *c.* twelfth century.

34. *Sardanapalus*, engraving by Jean Théodore de Bry, sixteenth century.

35. *The Self-Destruction of Sardanapalus*, engraving by George Cruikshank from George Clinton's *Memoirs of the Life and Writings of Lord Byron*, London, 1825.

36. *The Death of Sardanapalus*, engraving by Achille Devéria, 1825, from Byron's *Sardanapalus*, Paris, 1825. (Photo: Bibliothèque Nationale.)

37. *The Fall of Nineveh* by John Martin, 1827-8 (Photo: John R. Freeman.)

38. *The Death of Sardanapalus* by Francisco Lameyer y Berenguer, 1860s. Madrid, Private Collection (Photo: Rickfot-Giraudon.)

39. *The Last Days of Babylon* by Georges Antoine Rochegrosse, 1892 (Photo: *Connaissance des Arts*, J. Guillot.)

40. *A Modern Olympia* by Cézanne, 1872-3. Paris, Musée du Louvre (Photo: Museum.)

41. *Christ on the Sea of Galilee* by Delacroix, 1854. Zurich, Dr Peter Nathan Collection (Photo: Giraudon.)

42. *Michelangelo in His Studio* by Delacroix, 1850. Montpellier, Musée Fabre (Photo: Giraudon.)

43. Detail of *The Death of Sardanapalus*.

44. *Banquet Scene*, from B. de Montfaucon's *L'Antiquité expliquée et représentée en figures*, Paris, 1719-24.

45. Sarcophagus from B. de Montfaucon's *L'Antiquité expliquée et représentée en figures*, Paris, 1719-24.

46. *Disembarkation of Marie de Medici at Marseilles*, by P. P. Rubens, 1625. Paris, Musée du Louvre (Photo: Archives.)

47. Drawing by Delacroix after the *Disembarkation of Marie de Medici at Marseilles* by Rubens, 1820s. Paris, Cabinet des Dessins, Musée du Louvre (Photo: Museum.)

48. *Christ in the Garden of Olives* by Delacroix, 1824-7. Paris, Saint-Paul-Saint-Louis (Photo: Giraudon.)

49. *Birth of Henry IV* by Eugène Devéria, 1827. Paris, Musée du Louvre (Photo: Giraudon.)

50. Sketch for an illustration to Scott's *The Antiquary*, by Achille Devéria, *c.* 1829. Paris, Bibliothèque Nationale (Photo: Bibliothèque Nationale.)

51. *Lord Ure* by Delacroix, *c.* 1817. Paris, Cabinet des Dessins, Musée du Louvre (Photo: Museum.)

52. *L'Abbé Stialité* by Delacroix, *c.* 1817. Paris, Cabinet des Dessins, Musée du Louvre (Photo: Museum.)

53. *Deposition* by Delacroix, 1820s. Paris, Cabinet des Dessins, Musée du Louvre (Photo: Museum.)

54. *Pietà* by Delacroix, 1820s. Paris, Cabinet des Dessins, Musée du Louvre (Photo: Museum.)

55. *Copulating Couples* by Delacroix, 1820s. Paris, Cabinet des Dessins, Musée du Louvre (Photo: Museum.)

56. *The Death of Sardanapalus* by Delacroix, 1844. Philadelphia, Henry P. MacIlhenny Collection.

57. Detail of *The Death of Sardanapalus* (Photo: Museum.)

Index

Bold numbers refer to illustration numbers